Turner Watercolours

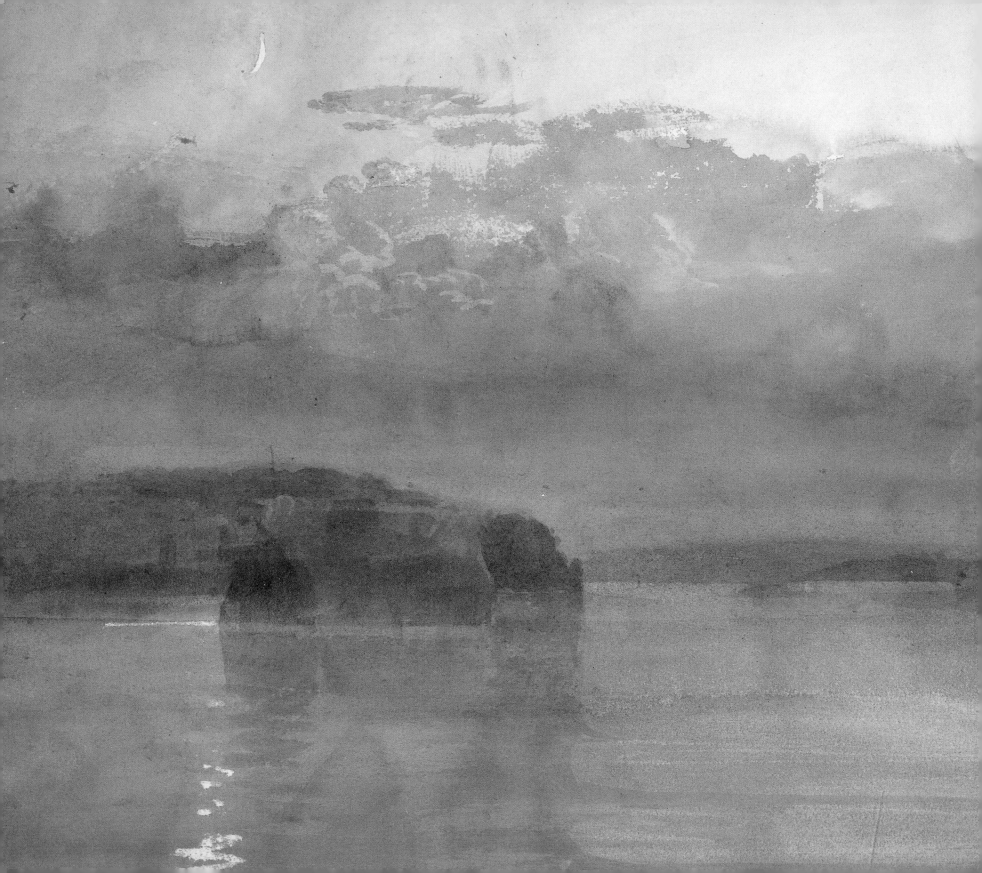

David Blayney Brown

Watercolours Turner

TATE PUBLISHING

Supported by BP

First published 2007 by order of the Tate
Trustees by Tate Publishing, a division of Tate
Enterprises Ltd, Millbank, London SW1P 4RG
www.tate.org.uk/publishing

on the occasion of the exhibition
Hockney on Turner Watercolours
Tate Britain
12 June 2007 – 3 February 2008

British Library Cataloguing in Publication
Data
A catalogue record for this book is available
from the British Library

ISBN 978 1 85437 771 5

Distributed in the United States and Canada
by Harry N. Abrams, Inc., New York

Library of Congress Cataloging in Publication Data
Library of Congress Control Number:
2007924375

Designed by 01.02
Printed by Graphicom SPA, Italy

Cover: *Venice: Looking across the Lagoon at
Sunset* 1840 (p.112, detail)
Frontispiece: *Hulks on the Tamar: Twilight*
c.1813 (p.48, detail)

Measurements of artworks are given in
centimetres, height before width.

Contents

Sponsor's foreword

BP is extremely proud to support the BP Summer Exhibition, *Hockney on Turner Watercolours*, the exhibition that this catalogue accompanies with such wonderful insight. Displaying some of the most magnificent studies of colour and light ever produced, Tate is to be congratulated on presenting a breathtaking appraisal of the genius of Turner's watercolour paintings.

BP aims to build long-term relationships with cultural institutions committed to excellence, such as Tate, and to use our support to give as many people as possible access to that excellence. BP has supported Tate for over seventeen years and has recently extended its support until 2012, allowing works to be shown in new contexts, as in the case of *Hockney on Turner Watercolours*, enabling Tate's Collection to be annually rotated through the *BP British Art Displays* and, of course, playing a major role in the redevelopment of Tate Britain itself in 2000. We are privileged to be partners of Tate and supporters of this compelling exhibition.

Tony Hayward
Group Chief Executive, BP

Foreword

Few people can seriously doubt that Turner was the greatest exponent of watercolour in its golden age. By almost any measure we can apply – technical refinement and virtuosity, variety of subject matter, range of output from spontaneous sketches to the grandest of exhibition watercolours – he stands alone. He was extraordinary in his time, and has continued to thrill and tantalise admirers since.

Thanks to the Turner Bequest of 1856, Tate's collection of his watercolours is extraordinary too, running to many thousands of works. The Clore Gallery opened at the Tate Gallery in 1987 and remains a shining highlight of Tate Britain. Among its many benefits was to bring together Turner's paintings and works on paper under one roof after decades of separation so his genius as a draughtsman and watercolourist can be seen alongside his pictures. But unlike the paintings, his watercolours can only be shown occasionally and in controlled conditions. Sadly, we have to ration their display for their own protection, but they may usually be seen on request in the Clore print room.

This book, presenting a selection of watercolours from the collection, is published on the occasion of the largest exhibition of Turner's watercolours ever mounted at Tate. This exhibition is unique, too, for bringing Turner together with another iconic British artist who, in later life, has confronted the challenges of the watercolour medium – David Hockney. Turner is not just an Old Master: he has always remained vividly alive for many artists. Hockney, who has lately returned to his Yorkshire roots and to painting in watercolour in the open air, brings his own contemporary insights and empathy to a much admired fellow painter. Earlier in 2007, we showed *Drawing from Turner*, a fascinating exhibition for which both established artists and art students made work responding to Turner's drawings. This was mainly an exploration of the monochrome media of pencil or chalk. Hockney, instead, addresses Turner the watercolourist, and above all as a painter liberated from outline who drew and thought directly with the brush.

One reason why artists respond so intensely to Tate's collection is that it is made up above all of the materials of a working artist. If there are any gaps they are in the sort of finished or exhibited watercolours that Turner sold in his lifetime. This book includes not only a majority of Bequest works – 'Turner's Turners', so to speak – but a number of subsequent acquisitions, of which the latest and most spectacular of all is *The Blue Rigi*, one of the greatest of all Turner's watercolours. It is thus another opportunity to express Tate's gratitude to the Art Fund, the National Heritage Memorial Fund, Tate Members, David and Susan Gradel, and all those members of the public who responded with such extraordinary generosity and enthusiasm to the campaign to save *The Blue Rigi* for the nation.

This published selection of Turner waterolours has been made and introduced by longstanding Turner scholar David Blayney Brown, drawing on choices made for the watercolour show along with his Tate colleagues Ian Warrell, Martin Myrone, Nicola Moorby, Matthew Imms and Philippa Allsopp. To them, to David Hockney, to BP, whose British Art Displays provide Tate Britain's core annual attraction, and to those at Tate Publishing who have made this book, my heartfelt thanks.

Stephen Deuchar
Director, Tate Britain

Introduction

David Blayney Brown

It is a sobering thought that the immense treasure of watercolours, drawings and sketchbooks that forms part of the Turner Bequest at Tate Britain would not survive together had Turner himself had anything to do with it. Like his unfinished pictures and sketches in oils, these were excluded from his plans for posterity: if enacted as he intended, his legacy would consist of just a hundred finished oil paintings and no works on paper at all. That it does not, and is instead such an extraordinary showcase for his genius as a draughtsman and his mastery of the medium of watercolour above all, is due to the independent minds of the Chancery Court who, in 1856, ruled that the entire contents of his studio should belong to the nation.

Turner was constrained by his hope that a Turner Gallery would arise at the National Gallery, which only collected pictures. But the impression given by these finished oils would inevitably have been limited. Turner was a draughtsman before he was a painter, and watercolours were the first works by which he made his reputation and living. He was a watercolourist all his life, making work for sale and exhibition, on commission, and above all to be engraved and reproduced. This accounted for a substantial part of his income. But just as his finished and exhibited oil paintings had a fascinating hinterland in the experimental works, sketches and pictures in progress in his studio, so his output as watercolourist and draughtsman was supported by a vast wealth of sketches and studies and by work 'realised', to borrow a phrase of John Ruskin's, 'for his own pleasure'. The Turner Bequest is proportionately rich in these as it is short of the finished, engraved or exhibited watercolours that left Turner's hands.

That is its special character. We should certainly not be embarrassed by a collection that gives such unique insights into a great artist's working methods, ideas and techniques. If there is an imbalance, the challenge is to correct it, and over the past twenty years we have acquired some very important watercolours of exactly the kind lacking in the Bequest. *The Siege of Seringapatam* (p.33) is a finished watercolour painted about 1800, probably for engraving to mark the capture of Tipoo Sultan's fortress by General Baird in May 1799. It shows the young Turner branching out into a subject from contemporary history; not having been to India, he may have worked from a drawing by a military draughtsman, Captain Alexander Allan, who witnessed the siege. *The Temple of Poseidon at Sunium (Cape Colonna)* (fig.1) of about 1834 was also made to be engraved, probably as a companion to a plate after a painting by Charles Eastlake also in Tate's collection. Here too Turner worked from a drawing by a traveller, the architect Thomas Allason, but raised his imagination to its highest pitch in the symphonic drama of storm and lightning, shipwreck and howling dogs that plays around the temple's colonnade and fallen metopes on their windswept promontary. To these finished watercolours, we have now been able to add even more remarkable works. *The Northampton Election, 6 December 1830* (p.70) was made,

in or after 1830, for Turner's most important series of engraved topography, *Picturesque Views in England and Wales*, for which only two watercolours were in Tate's collection hitherto. That *Northampton* was not published was no reflection on its quality, but rather of the enthusiasm with which it depicts the election of Lord Althorp to the reforming government of Lord Grey. Sold by subscription, the prints had to appeal to all shades of opinion, but today this subject stands out as a warmly sympathetic commentary on our national life at a time of momentous change. And finally we have acquired *The Blue Rigi, Sunrise* (p.119) of 1842, one of the most spectacular of all Turner's watercolours and a crowning achievement of his career.

While *The Blue Rigi* is a masterpiece by any standards, any one of the watercolours just described would represent Turner to great effect in a public collection. Together they display major phases of his art, his wide-ranging interests and the scope of his technical development. But at Tate, against the backdrop of the Turner Bequest, they fit into a story that is greater than the sum of even these splendid parts. Thus *The Siege of Seringapatam* joins pictures of Trafalgar and Waterloo as Turner's first surviving contemporary battle scene in any medium. *The Blue Rigi* takes its place alongside his first rough pencil sketch of the mountain, from a boat on Lake Lucerne, in a sketchbook of 1802 and many variant watercolour sketches of it in changing lights made on repeated visits up to 1844, as well as the more developed 'sample study' from which he made his finished version. Its two companions in watercolour, *The Red Rigi* and *The Dark Rigi*, were bought by the same art-loving Scottish laird, H.A.J. Munro of Novar, who once owned *Northampton*. Munro was Turner's companion on a tour of the Aosta valley in 1836, and watched him making studies of Mont Blanc, itself tinted by changing light (p.99). *The Temple of Poseidon* was a tribute to Byron, whose poetry Turner loved and illustrated in paintings and watercolours in the collection (p.101). Such networks and connections run deep and are worth emphasising to offset the argument that funds for trophy acquisitions should be raised by selling other works, as if any were superfluous or duplicates – surely, a counsel of despair. Turner, of all artists, deserves to be seen whole and complete.

Turner's mastery and perfection of watercolour coincides with its establishment as an independent art form. His lifetime was also the classic age of English watercolour, when practitioners seized higher status, formed their own societies and exhibiting bodies, and their work got bigger, leaped from the album and portfolio into frames and onto the wall, and found new patrons and collectors. Watercolour was more affordable, accessible and democratic than oil, in sympathy with the temper of the time and its rising middle class. It appealed to amateurs, women as much as men, many of them taught by the professionals who offered simplified versions of their trade-mark methods. It acquired an aura of modernity; and

Fig.1
The Temple of Poseidon at Sunium (Cape Colonna)
c.1834
Pencil, watercolour and gouache on paper
38.2 × 58.8
Accepted by H.M. Government in lieu of tax and
allocated to the Tate Gallery 1999
T07561

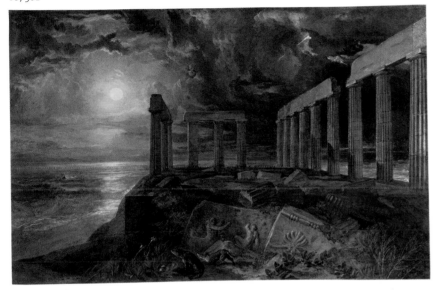

a flattering (if sometimes exaggerated) association with the national character in which foreigners colluded with the patriotic British themselves. For Romantic critics, especially those like Théophile Gautier who looked at it from outside, it was at once typically British and a model for the paradoxical blend of sophistication and spontaneity that they longed to set at the heart of contemporary aesthetics.

Turner was at the forefront of these developments, but he also stood apart from them. He never, for example, showed at the 'Old' Water-Colour Society, of which two close friends, W.F. Wells and James Holworthy, were founder members in 1804, but continued to send his watercolours to the Royal Academy where he made his name – though in a diminishing stream which dried up altogether in 1830. Beyond the Academy, his watercolours appeared in his own gallery from 1804 and in independent exhibitions, such as those held in the London house of his friend and patron Walter Fawkes in 1819 or in the premises of publishers and engravers – W.B. Cooke in 1822-4 or Moon, Boys and Graves in 1833 and 1834. Late in his working life he was selling direct to clients like Munro through an agent, Thomas Griffith; then, and as early as his first tour of the Alps in 1802, he obtained commissions by making draft or 'sample studies' to entice his collectors. He was constantly dreaming up new opportunities to promote his work and boost his income, and arguably too close an association with any partisan body (the new watercolour societies were soon in conflict) would have been a restriction as well as an irrelevance. Even if we set aside his private use of watercolour as a means of technical experiment, formal or colouristic exploration or study from nature, it is clear that his public watercolour career followed strategies wholly his own. Whether in variety of subject matter, technical development or the range of outlets through which it reached the public, it refuses to be pigeon-holed. Perhaps the most obvious proof of his distance from his contemporaries is that, having first cemented his reputation with some of the grandest of the new 'exhibition watercolours', he was by the 1820s making most of his commercial watercolours for the engraver, and quite comfortable with the idea that the print was the main avenue of communication with his public. But, never one to fit a consistent pattern, he returned in the 1840s to independent finished watercolours like *The Blue Rigi* that remain unparalleled expressions of the medium on its own terms.

From Architecture to Landscape: Early Work

Turner was never typical of his time. As a boy he chose one of the emerging career options for an artist – that of topographical draughtsman – and transformed it, first by raising the stakes of this particular game in scale, technique, ambition and price, then moving on to oil as well and showing his mettle as a serious painter. The master who spun gauzy, tinted mists over mountains and lakes began by rendering brick

and stone. By about 1788, when he was thirteen, he had got to know one moderately successful architect, Thomas Hardwick, and the following year he was working for the man he described as his 'real master', Thomas Malton, who drew buildings in colourful landscape settings. His job was to make presentation views, in convincing perspective and to scale in appropriate settings, to show clients how their projects would look when built. Did Turner ever think back to this sort of work when drafting his 'sample studies' of pure landscape in later life? At any rate, the skills he learned in these early exercises could usefully be transferred more widely, to the newly-booming industry of topographical view-making. A number of artists were making views of buildings and landscape, often for the engraver, in a typical house-style of the period, tinting careful outline drawings with touches of local colour applied over a monochrome ground of grey or grey-blue; Turner learned fast from them, then left them standing.

Among his early architect-contacts were the dynasty led by the fashionable James Wyatt. James was the architect of the Pantheon, the grand theatre and assembly rooms in London's Oxford Street whose destruction by fire Turner depicted in a big watercolour in 1792 (p.21). With its dawn light bursting through the now-roofless ruin on a frosty winter morning and crowd of firemen and onlookers, realised in confident draughtsmanship and evocative colouring, it was one of his earliest exhibits at the Royal Academy, where he had been a student since 1789. Far more than an architectural rendering, this raised urban topography to the status of art. Clearly, his independent skills, both technical and conceptual, were developing fast. Outside London, his growing sensitivity to nature and landscape soon put him in demand for views of country houses that were truly pictures, not visualisations on behalf of an architect. His views of great estates in the West Country, Stourhead (p.28) and Fonthill Abbey (p.29) sometimes focus more on gardens or parkland than the houses themselves, though Wyatt's work on Fonthill for William Beckford was probably the main reason why Turner was invited to stay there in 1799; the architect was present at the same time, and the previous year Turner had even exhibited a meticulous view of the Abbey (fig.2) under Wyatt's own name.

This seems self-effacing, but probably he no longer wished to be associated with so strictly architectural a subject. A few years earlier, he had been surprisingly self-assertive in trying his hand at pure landscape. On a visit to friends of his father's near Bristol in 1791, not only had his enthusiasm for drawing the Avon Gorge won him the nickname 'Prince of the Rocks' but he thought of getting the results (p.20) engraved as 'Twelve Views of the River Avon'. The teenage entrepreneur's skills soon caught up with his ambitions. So did his working routine. During this early decade he began the summer touring he continued for most of the rest of his life, first at home and then on the Continent, taking his sketchbooks with him and collecting sketches and memoranda to convert into finished works during the winter months. A comprehensive tour of the north of England in 1797 produced a rich harvest of landscape, architectural and antiquarian subjects that could be worked up for years afterwards. *Interior of Durham Cathedral* (p.27) is virtually a finished work, which could easily have been made ready for exhibition. *Richmond, Yorkshire, Sunrise* (p.26) and *Norham Castle, Sunrise* (p.25) are colour studies, developed from on-the-spot materials in anticipation of separate, finished versions. Integral to them is Turner's preoccupation with effects of light and specific timing, which aspires to naturalism even at one remove from his subjects and shows off his growing technical sophistication.

Where did this come from? Much has been written about his various encounters with other artists' work. Among the topographers, he learned from Michael Angelo Rooker what was called 'scale practice' – working with one colour at a time, beginning with the palest tone wherever it was needed and then building up with progressively deeper ones. This could produce subtle and minute variations in foliage or masonry (fig.3). But such precision worked best when it was contrasted with breadth, and tonal variations were not just applied to details but orchestrated throughout a composition. Here Turner's evenings during the mid-1790s in the Adelphi 'Academy' of the collector Dr Monro, copying other artists, were invaluable, not least for bringing him into contact with the work of John Robert Cozens, whose watercolours of Switzerland and Italy were realised in a much more limited palette than Rooker's but were vastly more atmospheric and suggestive. Turner worked alongside his contemporary Thomas Girtin, washing in 'the effects' on Girtin's pencil 'outlines', which as Girtin ruefully admitted, gave his friend the better 'chance of learning to paint'.

It is easy to see how such practice helped move Turner on from the conventional 'tinted drawing' – the staple of the topographers – to drawing and thinking with the brush. In fact, his spell of study at Monro's coincided with his first efforts as a painter in oil, and the lessons he learned there were no longer to be confined to watercolour alone and were as much conceptual as technical or material. This is especially true of experiments in tonal contrast and chiaroscuro dating from around the middle of the decade, which can be related to early oils including his first Royal Academy exhibit in 1796, a moonlit marine, and to an interest in Rembrandt and Dutch painting which might have been encouraged by Monro but was also very much of the time, as Dutch pictures from Continental collections came onto the London art market and were snapped up by collectors. *Windmill on a Hill* (p.22) doffs its cap to one of these, Rembrandt's *Mill*. Though modest in size this was carefully worked and set in a lined and washed mount, perhaps as a gift for a collector's album (perhaps even for Monro?). The *Internal of a Cottage* (p.23) was in fact exhibited in 1796, and

Fig 2
James Wyatt (1746–1813 and J.M.W. Turner
Projected design for Fonthill Abbey, Wiltshire
1798
Watercolour on paper
67 × 105.4
Yale Center for British Art, Paul Mellon
Collection

Fig.3
**An Octagonal Turret and Battlemented Wall: Study of
Part of the Gateway of Battle Abbey, after Michael Angelo Rooker**
1792–3
Pencil and watercolour on paper
17.2 × 14.6
Bequeathed by the artist 1856
D00193

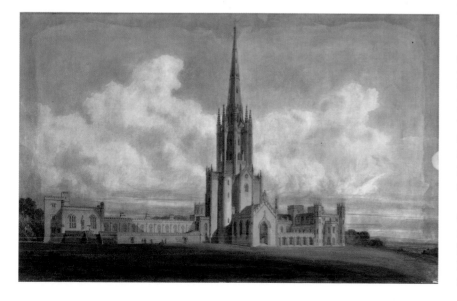

notwithstanding its subtitle 'Study at Ely' was also Dutch-inspired, recalling the low-life genre of David Teniers or Isack van Ostade. At the same time these works played to the contemporary taste for the Picturesque, promoted by fashionable pundits like Richard Payne Knight.

Turner could also play off contrasts of moonlight effects, highly contrived in a transparency reminiscent of those made by Thomas Gainsborough or Philip James de Loutherbourg, designed to be illuminated from behind, or observed, surely, from nature over the sea at Brighton (p.24). They communicate a sense of a newly-confident artist, increasingly sure of his handling and materials, practising his skills and sharpening his eyes. As an oil painter Turner would spend a great deal of time and energy imitating other artists, including the Old Masters. But he soon outgrew the habit in watercolour, whether in style or technique. There are, for instance, no imitations (as opposed to Monro copies) of Cozens, and such sources were either hidden, combined or ignored as occasion demanded. By 1799 he claimed to have broken free of familar practices, having, as his colleague Joseph Farington reported, 'no systematic process for making drawings – he avoids any particular mode that he may not fall into manner. By washing and occasionally rubbing out, he at last expresses in some degree the idea in his mind'. And Turner 'reprobated the mechanically systematic approach of drawing ... so generally diffused. He thinks it can produce nothing but manner and sameness'. He had already given up any attempt to teach drawing or watercolour, a lucrative sideline for many artists. Instead he aimed higher, with watercolours as big and impressive as oil paintings. *Caernarvon Castle, North Wales* exhibited in 1800 (p.30) was one of a crop of these, based on a Welsh tour in 1799. In its chosen medium, no less than its theme and style, it is a richly suggestive work whose implications were also developed in verses probably written for it by Turner himself. A bard sings a 'song of pity', lamenting the 'tyrant' – Edward I of England – who crushed the Welsh and built the castle to secure his dominance. Historical particulars aside, the larger theme is national liberty, to which the current threat was Napoleon. To tell the story, Turner moulded the scenery into one of his first imitations of the seventeenth-century French painter Claude Lorrain, whose pictures, like those of Dutch artists, were pouring into English collections. But he did so in the 'English medium' of watercolour, an assertion of liberty in itself.

Welsh tours in the late 1790s, one of Scotland in 1801 and his first visit to Continental Europe, to France and the Swiss Alps in 1802, introduced Turner to materials that would inspire some of his finest watercolours – amphitheatres of lakes and mountains on which played shifting dramas of weather and light. In his hands, the medium was made for them. In Scotland and Switzerland, he made numerous monochrome studies in pencil or chalk, which treated their subjects

mainly in terms of tone; he had an excellent visual memory for colour and did not always need to depend on coloured sketches from nature. But he coloured many of his drawings too, if not on the spot then perhaps shortly afterwards. Bold and vivid, they show his visceral response to scenery that was often harsh or frightening, or associated with recent fighting in the French revolutionary wars as in the Schöllenen Gorge or around the Devil's Bridge (p.37). Back in London, Turner showed them to colleagues and patrons, and some, notably his friend Walter Fawkes, commissioned finished versions which remain among the most spectacular watercolours Turner ever made. Judging by its size and grandeur, *The St Gotthard Road between Amsteg and Wassen looking up the Reuss Valley* (p.36) is probably one of these, left unfinished. The complex techniques of his first maturity are all here; the richly layered palette, the details applied with a semi-dry brush over broad washes, the scratching or stopping-out of highlights with brush handle, finger nail or damp cloth. But the design retains the brilliance and spontaneity of work in progress.

Nature and the Ideal: Work in England to 1815

Looking at such works, it is hardly surprising that Turner sometimes preferred to show them at his own London gallery, opened in 1804, where he could control the hanging, rather than in the Academy where they were crowded out by pictures hung frame to frame, 'skied' or put in lesser rooms. But he continued to send to the Academy too, and the grand watercolour for which *The St Gotthard Road* may have been begun as a companion, *The Battle of Fort Rock* (fig.4) appeared there in 1815. The one unfinished, the other complete, these represent the watercolour-as-picture at its most ambitious, claiming equality with oil. Turner had scored a huge march on his painter-colleagues in 1802 by snatching an Alpine tour from the short-lived 'Peace of Amiens' and stocking up with such spectacular landscape material. It justified displays of virtuoso brilliance. By contrast, his work at home when war resumed was marked by intimacy and freshness. Nowhere are these qualities more clearly seen than in his sketches outdoors from nature along the Thames. Whether working on the page of a sketchbook or on canvas, his methods were now remarkably similar. Watercolour was applied freely and thinly over little if any under-drawing in pencil, leaving the paper bare where highlights or reflections were needed; oils were brushed in similar fashion over an off-white preparation. Having raised watercolour effects to those of oil, Turner was now mimicking the distinctive features of watercolour, its transparency and spontaneity, in the more solid medium, and he took care to carry them into finished pictures. From 1806 his gallery showed numerous canvases of pastoral Thames scenery. Perhaps the watercolour known as the 'Swan's Nest', *Syon House and Kew Palace from near Isleworth* (p.40) was intended for exhibition with them as it is on the same grand

exhibition scale as the earlier *Caernarvon* and the later *Fort Rock*.

Among the few works on paper known for certain to have been shown at Turner's gallery was a set of landscape designs for the *Liber Studiorum*, hanging there in 1808. They must have been intended to publicise the venture. The *Liber*, comprising compositions of various landscape types and intended to demonstrate the variety and potential of the genre as well as Turner's own mastery of it, was published in sets of mezzotints. Turner's designs for them were made in a restricted palette of sepia and watercolours including umbers, siennas and ochre (not sepia alone as is often said). Later on, as his palette brightened and he began to revel in the new pigments coming onto the market, he challenged his engravers with designs of dazzling brilliance, using colour as the stimulant to line. But such is the mastery of tone and range of lighting in the *Liber* drawings that colour seems, for the time being at least, a frivolous indulgence. Among the mountainous, marine, architectural, pastoral and historical subjects, sometimes drawn from Turner's existing work and sometimes newly invented, the bridge is a recurrent motif, in a Claudean idyll (p.46) or over a stream in the Grande Chartreuse (p.47), as if it could span the territories of nature and the ideal, domestic and European, experience and memory that his art now embraced. The *Liber* was the first important publishing project to be planned by Turner himself, and it showed his mind rising far above the restrictions imposed by the war.

Turner had been making watercolours for the engraver for some time, but for the *Liber* he was closely involved in the process of reproduction, generally providing etched outlines or soft-ground etchings himself and supervising the engravers who added the tone in mezzotint. Thus began his close association with teams of brilliantly talented engravers, and reciprocal relationships in which all learned from each other. As he got to grips with the technical aspects of engraving, he began to think about what the engravers needed from him, but also how he could prod them into making their own contribution. While some of his *Liber* designs were reproduced literally, in almost exact transcriptions, others served only as points of departure for images that evolved through collaboration. The full implications of this would be felt only in the following decades. Meanwhile, he was also developing the sorts of working studies that he made for his own use. While preparing the *Liber*, around 1811, he received, from the engraver and publisher W.B. Cooke, the first of many commissions for a series of topographical watercolours for publication in serial form. *Picturesque Views on the Southern Coast of England* was to survey the coastline for Kent to Somerset. It was soon followed by a similar commission for a *Rivers of Devon*. Besides his specific designs, his visits to the West Country produced some independent studies painted in broad washes, often in muted colours (sometimes trialled in the margin) focusing on the essentials of a subject, which

Fig.4
The Battle of Fort Rock, Val d'Aouste, Piedmont, 1796
exh 1815
Gouache and watercolour on paper
69.6 × 101.5
Bequeathed by the artist 1856
D04900

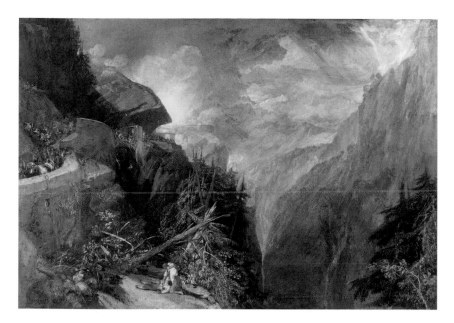

nevertheless convey great subtlety in the handling of light. Some already look like worked-out compositions, but *Hulks on the Tamar* (p.48) is the record of a powerful motif which Turner used differently in an oil painting. If he was now evolving a particular sort of preparatory colour study, setting out the tonal map of a composition, he seems to have first used it more systematically for his designs for a further topographical commission, Dr Thomas Whitaker's *History of Richmondshire*. Various colour studies of Yorkshire scenery from a tour in 1816, like *Kirkby Lonsdale* (p.54), show the process in action. And it was for his Yorkshire patron, Walter Fawkes, that Turner first used or suggested the term 'beginning' by which such colour studies have become known; *Loss of an East Indiaman* (p.51), which prefigured a finished watercolour for Fawkes, is inscribed 'Begun [or 'Beginning'] for Dear Fawkes of Farnley'.

Fawkes occupies a special place in Turner's history as a watercolourist. Not only was he a great collector, who had ordered some of the most important finished watercolours based on Turner's Swiss tour in 1802 among many major commissions, but he was closely acquainted with Turner's working practices. The Fawkes daughters remembered Turner's bedroom at Farnley Hall in 1816, strung with cords like a laundry room with papers (perhaps more beginnings) 'tinted with pink and blue and yellow' hung up to dry. And their brother left the most vivid of all descriptions of Turner at work, when, in three hours after breakfast at Farnley, he made his famous watercolour of a man-of-war, *First-Rater, Taking in Stores*; the *Indiaman* was perhaps laid in for future reference with the same brushes and pigments while Turner waited for the underpainting of the *First-Rater* to dry, and when ready he continued 'under Mr. Fawkes's observation ... tearing up the sea with his eagle-claw of a thumb-nail, and working like a madman; yet the detail is full and delicate, betraying no sign of hurry'. Here, there was no time for an intervening study and the picture grew from nothing, from Turner's memory in an outburst of technical fireworks, ends justifying means. Turner's parallel skill in gouache or bodycolour was put on show at Farnley in a set of twenty views, interior and exterior, of the house and estate, and a still more impressive set of fifty views of the Rhine, based on his first return to the Continent after the war, in 1817. These too were a collective display of virtuosity. Neither made on the spot nor on the tour, they were worked up very quickly on his return, probably at Raby Castle on his way to Farnley in autumn that year, and on arrival he was apparently so eager to show them to his host that he grabbed them from his breast-pocket before he had even removed his coat. Again, haste left no time for colour studies and he worked direct from the pencil sketches in his sketchbooks, using watercolour and gouache on white paper prepared with grey wash. *Sooneck with Bacharach* (p.62) is a colour beginning for a larger, more elaborate treatment of the Fawkes version, made somewhat later.

Home and Abroad: Watercolour and Gouache in the 1820s

By 1819 Fawkes's collection had reached such proportions that he threw it open to the public in an exhibition at his London house, 45 Grosvenor Place. No more comprehensive collection of Turner's watercolours then existed, and when shown alongside works by contemporaries including the likes of John Varley, Peter De Wint, David Cox, Joshua Cristall and Copley Fielding, it attracted huge attention. The many reviews enable us to guage Turner's standing as a watercolourist at perhaps its highest point before its apotheosis, through the pen of John Ruskin, in the 1840s. At least one critic (and the same one who described his oils as 'intoxicated freaks') thought Fawkes's Turner watercolours the work of an 'astonishing magician'. Another wrote of the 'admirable truth and nature' that distinguished them from the 'poetical feeling' of his oils. A third (among many) put him 'indisputably *in this department of art*, at the head'. While others thought Turner matched his themes with an 'exalted' style, most interesting and far-sighted of all was the writer who preferred more informal and intimate works like the Farnley gouaches; 'the sketches of a master possess more charms than the laboured results; and to all men of taste they afford grounds for the imagination to fill up, as fancy willeth, every vacant space and unfinished outline'. Here indeed is the true voice of the Romantic mind, and this writer would certainly have admired much that Turner went on to do in the next decade, not least the gouache studies of interiors and parkland at Petworth, the Sussex home of Turner's other great friend and patron Lord Egremont (pp.72–5). Petworth, in fact, replaced Farnley as a home-from-home for Turner after Fawkes's death in 1825, and whereas the Farnley views were finished for its proprietor, those of Petworth were still more intimate and immediate and were made by Turner for himself.

For his Petworth studies, Turner again used gouache but on smaller sheets of blue paper. He is supposed, on one occasion at least, to have described gouache as a vulgar medium, 'beastly stuff'. But it suited the higher colour key of his later work. The vivid reds, yellows, blues and Chinese whites were applied quickly and deftly, with a touch as sure as it was economical, so that the designs still convey a wealth of information, enabling the décor and splendid contents of these light-filled rooms to be recognised or reconstructed. Here was a very different strand in his work to the limpid watercolour studies of Como and Venice he had made during his first visit to Italy in 1819 (pp.58–9). These explored, as never before in his work, watercolour's luminosity and transparency, with wet, thin washes merely floated (or 'flirted', to borrow the word of a contemporary) over the surface of the paper, and they certainly left space for fancy, Venice's buildings rising as if in a dream. Yet there is already a hint of the Petworth studies in the gouache or mixed media studies Turner went on to make in and around Rome, in richer colours and again on toned paper (pp.60–1).

None of these, of course, were intended for eyes other than his own. They were confided to his sketchbooks, stored as a memory bank of images and effects. Turner made them selectively, for as he said, he could make fifteen or sixteen pencil drawings in the time it took to colour one. But this means that we should pay particular attention to his choice of medium when he did decide to colour – pure watercolour for the mists, vapours and reflections of Venice or the Italian lakes, gouache for the hotter, drier atmosphere and more substantial architecture of Rome and the Campagna. In retrospect, the Italian work of 1819 can be seen to have introduced a certain dualism into Turner's work on paper that he developed in the next two decades.

Perhaps most clearly, it is seen in his work for the engraver. For two projects of the 1820s, *The Rivers of England* and *The Ports of England*, commissioned like the earlier *Southern Coast* by W.B. Cooke, he made watercolours for translation into mezzotint. Just as these small designs (pp.66–7) achieve a wonderful blend of breadth and concision in their expansive perspectives and wealth of life and detail, so the processes of their execution run the gamut from the first laying-in of generous fields of colour to their development by delicate hatching or stippling with brilliant colour using fine, even single-haired brushes, like a miniaturist or even a jeweller setting his gems. This looks painstaking but was probably the work of hours rather than days, for as the painter James Orrock remembered being told by one of Turner's colleagues, the master's mature practice was 'prodigiously rapid' and involved working on four subjects at a time, the papers stretched on boards with a convenient handle on the back:

> After plunging them into water, he dropped the colours onto the paper while it was wet, making *marblings* and gradations throughout ... His completing process was marvellously rapid, for he indicated his masses and incidents, took out half-lights, scraped out high-lights and dragged, hatched and stippled until the design was finished.

Turner refined these methods in the larger watercolours for his greatest topographical series, *Picturesque Views in England and Wales*, where they could convey the glistening surface of water in *Aldborough* (p.69) or the busy crowds of election-day in *Northampton* (p.70). The magnificent *Folkestone from the Sea* (p.68) is another scintillating display, not least in the sky whose untimely transition from moonlight to dawn has exposed a group of smugglers to a Customs cutter; this was probably made for another Cooke project, *Marine Views* but superseded by a different version of the same subject. But for the publisher Charles Heath's intended survey of *Rivers of Europe* of which only views of the Loire and the Seine were published (1833; 1834–5), Turner used gouache on blue paper. Perhaps this was because he was reminded of his earlier Rhine series for Fawkes, or another explanation might be simply that he could work still more quickly this way.

The Annual Tourist: Designing for the Engraver in the 1830s

Whatever the motive, these two series of French rivers, of which only the Seine views remained in his possession, were a sustained exploration of saturated colour as the basis for black and white engraving. And they were the only ones in which he used gouache and coloured paper for finished images as well as sketches. 'Finished' must be used advisedly, for while some, including his views of Paris (p.91) are worked up with a wealth of detail, others are swift and sketchy, with even quite important features suggested by mere dabs of colour and highlights or sunlight by blizzards of white stippling. Beneath, the coloured paper assumes the role of a preliminary watercolour wash, serving as the mid-tone above or below which the accents are placed. Since it is the function of open-edged vignettes to grow from the paper, the method is perhaps best seen in examples like *Light Towers of the Héve*, designed for the series along with the landscape plates, where process and image seem perfectly matched. And in so far as it clarified tonal contrast, progression or spatial recession, it probably helped the line engravers to realise the full potential of Turner's designs. His vagueness over detail must have been a different matter and the engravers were thereby compelled to respond more creatively and interpretatively. This was surely a good thing, for whether through his assistance or their skill and intuition, the images gained rather than lost in translation. But although he continued to use gouache and blue paper for many other views on his travels on the Continent in the 1830s and 40s, he did not use it alone again for engraving.

Watercolour had been Turner's preferred medium for his vignettes for the 1830 edition of Samuel Rogers's poem *Italy* (pp.76–9) and remained so for those in Rogers's Poems (p.100), and for Byron (p.71), Milton and other writers. Within their tiny compass these convey infinite space, a wealth of detail, incident and suggestion and – most strikingly – the historical span of a millennium. Views of Rome for Rogers (p.78) and Byron encompass the ancient and modern city, the profane and the sacred, the classical and the baroque, even life and death as citizens watch a Punch and Judy show beside the Tiber or carry a coffin across the Forum. In *Marengo* (p.76) Napoleon's white charger, picking his way down from the Alps to the site of his master's greatest victory, is borrowed from the portrait by Jacques-Louis David that Turner had seen in Paris in 1802. The handling is no less suggestive than the imagery, brilliant ultramarines or reds among other vibrant tints marking out the lights and shadows for the engravers. It is not naturalistic colouring, and does not have to be; however idiosyncratic, it conveys texture, space and tone, for as Ruskin said, 'He (Turner) paints in colour, but he thinks in light and shade'. The same could be said of the dazzling *March of the Highlanders* (p.102), one of a set of *Illustrations to the Waverley Novels* of Walter Scott, including both landscape and vignette compositions, made in the mid-1830s. Here Turner's iconography was perhaps

less sure-footed, and Scott himself complained of the artist's tendency to resort to 'highlanders in every Scottish scene'. But as in the vignettes, and on as small a scale, he has built a wealth of detail and conjured up some shimmering atmospherics in his panorama of Edinburgh.

A note in Rogers's own copy of *Italy* tells us that Turner's original designs were returned to him after engraving because 'the truth is, they were of little value as drawings'. This is not a view borne out by posterity, for they were among the first works from the Turner Bequest to be exhibited, and from Ruskin onwards they have been treasured as the finest of Turner's book illustrations. Rogers (a rich amateur and to some extent a vanity publisher) was, for today's taste, the least of the poets and writers represented by Turner, but he knew him the best, and his allusive habits of thought chimed with the artist's. Hence the conceptual richness of these tiny designs. But their technical interest as points of departure for the prints should not be under-estimated. In being able to see and study them today, we have privileged access to the creative process. Other designs for prints, however, were exhibited in Turner's lifetime, as works of art in their own right or to promote the publications for which they were made. Thus W.B. Cooke showed a number with other watercolours old and new, including watercolours for the *Marine Views* in 1823 in his smart premises in Soho Square, and Charles Heath, publisher of *England and Wales* put nearly forty watercolours for the series in display at the Egyptian Hall, Piccadilly in 1829. Heath's successors Moon, Boys and Graves showed a further sixty-six, including *Northampton*, in their Pall Mall gallery in 1833.

While many of Turner's engraved watercolours remained in his own possession these, exceptional in so many ways, were sought-after collectables and in 1831 and 1832 selections were also shown to artists and the public on their owners' initiative. These were such significant occasions because Turner was exhibiting so few watercolours himself. Tate is fortunate to possess the last that he sent to the Royal Academy, *The Funeral of Sir Thomas Lawrence* (p.71), his poignant, wintry farewell to its late President which he inscribed as a 'sketch from memory'. As a pall-bearer that snowy day, he could not have sketched it on the spot, but in fact its respectful crowds made it more a work of imagination, as the funeral had been under-attended. These strange, stunted figures are not unlike those of the electors in *Northampton*, whose awkwardness – along with their politics – may have accounted for the omission of the subject from the engraved *England and Wales*. What seems to have been Turner's last exhibited watercolour, *Bamburgh Castle*, which he sent to the Graphic Society in 1837, may have been another unused subject for the series. Tate holds Turner's spectacular colour beginnings (p.104–5) for this dramatic image of wreck and rescue beneath a boiling sky, which the 1837 catalogue described as 'one of the finest watercolours in the world'.

Hand and Heart: The Late Watercolours

In fact, its author had seen nothing yet. The last decade of Turner's working life, into the mid-1840s, was to produce many of the finest of all his watercolours. They were created against a backdrop of changing tastes and clientele; and no longer for exhibitions or publishers, but for a restricted circle of collectors and admirers who ran apart from or ahead of the current. A turn in the critical tide may have made Turner more wary of exhibiting new work, for although proud owners like the Fawkes family continued to lend earlier work to exhibitions where they were well received, not all critics were as warm as the unnamed writer in 1837. What would be the height of praise in a modern tabloid – 'Hot! Hot! Hot!' – denounced the high colouring of the *England and Wales* and other watercolours at Moon, Boys and Graves in 1833. *England and Wales* was actually a failure as a commercial proposition, exposing a fall in demand for topographical prints for which Turner himself was partly responsible, a victim of his own success with so many prints after his work already on the market. This is not to say that he entirely stopped working for the engravers, and for one of them, Thomas Prior, he made a splendid watercolour of Heidelberg to give him a project when he needed work. Tate's large colour study of the town and castle is dated slightly later, '10 Mar[ch] 1841', and thus probably relates to another version of the subject. With rainbow and sunset effects, the two Heidelbergs must have been conceived as pendants, which would have independent market value; having sold the first to Prior for a hundred guineas, Turner released another while Prior, once he had finished his print, sold his version on to B.G. Windus, already a great collector of Turner. It was this sort of watercolour, for this sort of client, that dominated Turner's commercial output in the medium in his later years.

His private output became more prolific and relaxed as the pressure of his big print projects diminished. To paint was again a pleasure without the necessity of drawing, or collecting information to order. In the Aosta valley in 1836 he travelled with a client and collector, but one who was also a friend – Munro of Novar. Munro, like Windus, was one of the most nurturing of his late patrons, keen to possess prize works. But as a travelling companion he was a fellow artist as much as a client; they sat down to sketch together, Turner usually grabbing the best positions with the farthest vistas (p.91). 'I don't remember colours coming out till we got into Switzerland', Munro told Ruskin; when they did, he remembered that Turner used a sponge to create his 'misty and aerial effects'. Usually, on later visits to Venice, Switzerland or the Rhine, Turner travelled by himself and to his own timetable. In his pocket were loose-bound, rolled sketchbooks, pencils and a small travelling case of watercolours (fig.5). Once constantly on the move, filling smaller books with memoranda in pencil and pen, the habit as urgent and compulsive as a nervous

tic, now he had leisure to return to the same places, hour after hour, year after year, watching and recording different lights and weather. Was Ruskin right in thinking that Turner never used watercolour on the spot? Surely not in many of these late studies made from more settled and regular positions like his favourite hotels in Venice or overlooking Lake Lucerne. However fine-tuned his memory, colour seems absolutely integral to his immediate response. And in these conditions too, he could refine and distil watercolour to a perfection hardly seen before. This process came largely to an end in 1845, when, on his last trips out of England, to the coast of Normandy in 1845, he produced a wonderful series of limpid studies of sea, shore and sky, like many he had been making for years for their own sake, leaving no discernible trace of their actual date or location, but even more confidently focused and deft. He carried the same confidence, too, into the nave of the cathedral at Eu (p.125), the sort of antiquarian/architectural subject on which he had cut his teeth half a century before. Once he would have lavished detail on it; now he made it a study in shadows. Impressions like these, reductive and abstract, seem to us sufficient to themselves and have often tended to form our idea of the artist's identity. But it should never be forgotten that they were private outpourings, only a few of which could ever have reappeared in the public domain and then only if transformed. One of the pages from the 1845 Normandy sketchbook is inscribed, 'I shall use this', but there Turner added an imaginary gloss to a scene observed – a stranded whale. Perhaps he had in mind a subject for another of his special collectors, the whaling magnate Elhanan Bicknell.

Windus, Munro and Bicknell, along with Henry Vaughan and the young Ruskin, were at the heart of the small and exclusive group who collected Turner's later watercolours. Well as he knew most of them, he did not always deal with them himself. Since perhaps as early as the late 1820s and certainly from 1840, he used Thomas Griffith to market his work. A complex and still elusive figure, something between a collector and dealer, Griffith was described by the *Athenaeum* as 'an amateur of pictures ... engaged in the delicate task of smoothing the difficulties which occasionally arise between painters and their patrons'. At various times he owned or had for sale a number of Turner's *England and Wales* and Byron watercolours, also handled Turner oils and was sufficiently trusted to be named along with Munro and Ruskin as one of the artist's executors, a responsibility he turned down in case of conflict of interest with his dealing. He had in fact introduced Ruskin to Turner, at dinner at his Norwood home in 1840, and he orchestrated the commission or purchase of the artist's final triumphs as a watercolourist; four sets of finished watercolours of Swiss scenery made between 1842 and 1848. Turner himself had shown the drawings from his 1802 Swiss tour to collectors like Fawkes, who placed their orders with him. Now Griffith acted as intermediary, using intermediate

Fig.5
**Travelling watercolour case, apparently improvised by
Turner himself from the cover of an almanac**

materials – 'sample studies', worked up from the drawings Turner had made on the spot – to show to clients as bait. They would then commission finished versions.

To involve collectors so personally in choice of subject might be thought to sacrifice the autonomy of the artist, but it was nevertheless a notable step in the democratisation of art. These mainly self-made, middle-class collectors were offered an opportunity seldom allowed to their aristocratic predecessors. In 1842, to show them how their choices might look in final form, they were also offered four finished watercolours, themselves made from similar samples. Two of these were *The Blue Rigi* (p.119) and *The Red Rigi*, views of the mountain wearing its sunrise and sunset colours. The subject was dear to Turner and he pulled out all the stops. *The Blue Rigi* is perhaps the greater *tour de force* conceptually – a hunter's shot serving as a morning gun, dogs and frightened ducks breaking the surface of the lake which still reflects the brilliance of Venus. It is also a technical miracle in its delicately layered washes and overlapping veils of hatching and stippling. The two Rigis were priced at eighty guineas, more than had been charged for *England and Wales* watercolours but less than the hundred Turner had hoped for. Griffith had warned him that their new style

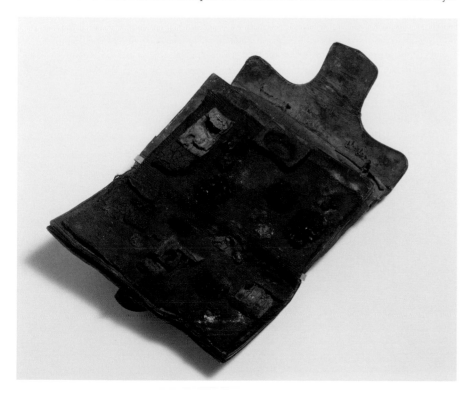

and treatment, less busy and highly coloured, more subtly atmospheric, might prove challenging even to his most recent admirers. And indeed it turned out that this last venture was not an unqualified success, getting fewer commissions during this and the following years than Turner had expected. But his friends rallied round, Bicknell buying *The Blue Rigi* and Munro the *Red*. Munro also seems to have commissioned a third view, *The Dark Rigi* to give himself a tonally contrasted pair, representing sunset and daybreak, and three other subjects from the first batch of samples. To these he added a further six, from the samples presented in 1843 and 1845. Among them was the finished version of *Küssnacht, Lake of Lucerne*, a view of the northernmost stretch of the lake. Already in Tate's sample study (p.120), boats glide on the water in front of the little town with its church, school and hall and the sun has climbed higher in the sky. But wooded slopes on the right are still in shadow, washed in a darker green. In the finished version, Turner clarified the architecture and narrative and harmonised it with a golden glow before emphasising this passage with rich green gouache.

Ruskin, who acquired a number of examples of the Swiss series for himself, had no doubts as to its importance as a final artistic statement. He wrote that 'Turner had never made any drawings like these before, and never made any like them again'. In them, he saw not just Turner's hand but his heart. But Ruskin came to treasure the sample studies, and the watercolours made closer to the scene or on the spot just as much. When Turner died and Ruskin began to salivate at the prospect of a studio sale, he wanted to buy all his late Swiss sketches – those made, in other words, during the years when he was discovering Turner's art and the places Turner visited for himself, and their journeys overlapped if their paths never crossed. When the Chancery Court decided differently, Ruskin gave himself a consolation prize. What he could not collect he would curate instead. Like Griffith, he had resigned as an executor, but now he undertook to organise the drawings and watercolours in Turner's estate and show them to the public. His prototype selection, published in a catalogue in 1857, included many of the sample studies among other Swiss and Continental watercolours from the 1840s – the majority of them made by Turner for himself alone. For Ruskin this was a learning experience as well as a labour of love, for he had not seen Turner's work of this kind before. He admitted that he 'thought them beautiful – but sketchy and imperfect compared with his former works', and his comments in the catalogue veer wildly from the harsh to the gushing. *Lake of Geneva and Dent d'Oche* (p.118) was, unaccountably to modern eyes, 'Out and out the worst sketch in the whole series; disgracefully careless and clumsy'. But of another, 'the grandest', he wrote: 'I will say no more of it at present than that it deserves the spectator's closest attention, and the artist's most reverent study'. How lucky we are that we can give just such attention not only to Turner's last watercolour sketches and studies, but to those from all stages of his career.

From Architecture to Landscape
Early Work

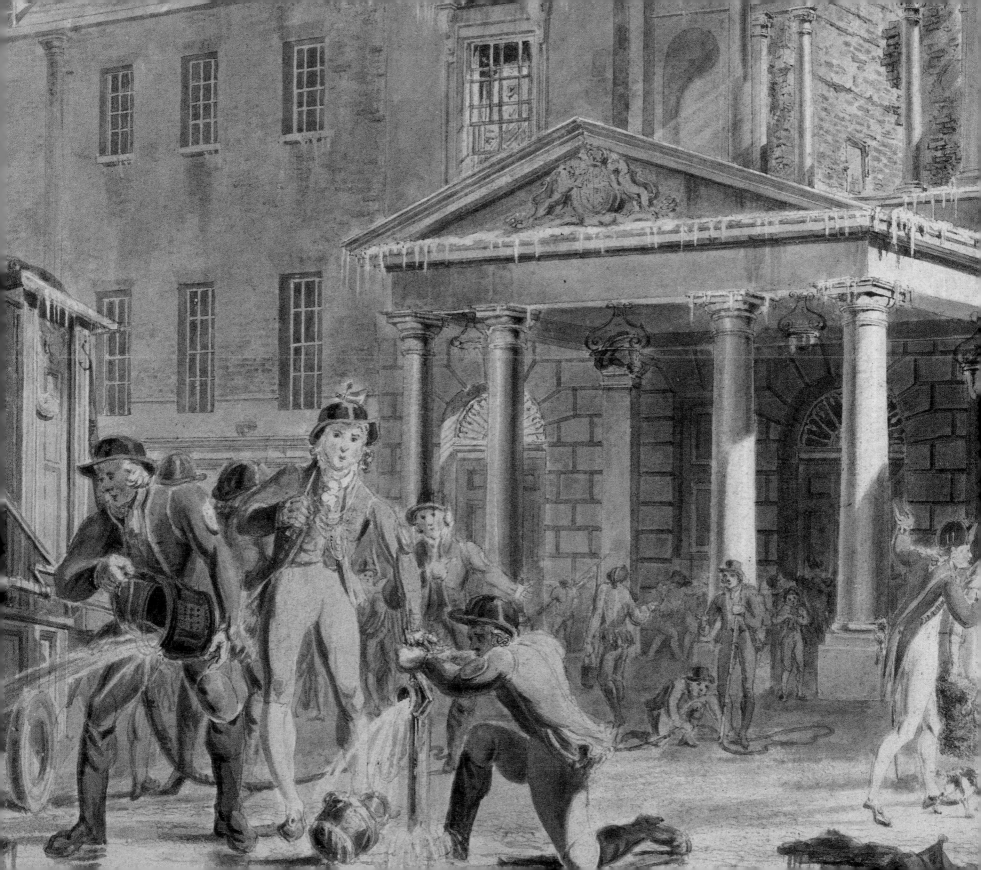

View in the Avon Gorge
1791
Pen and ink and watercolour on paper
23.3 × 29.4
Bequeathed by the artist 1856
D00114

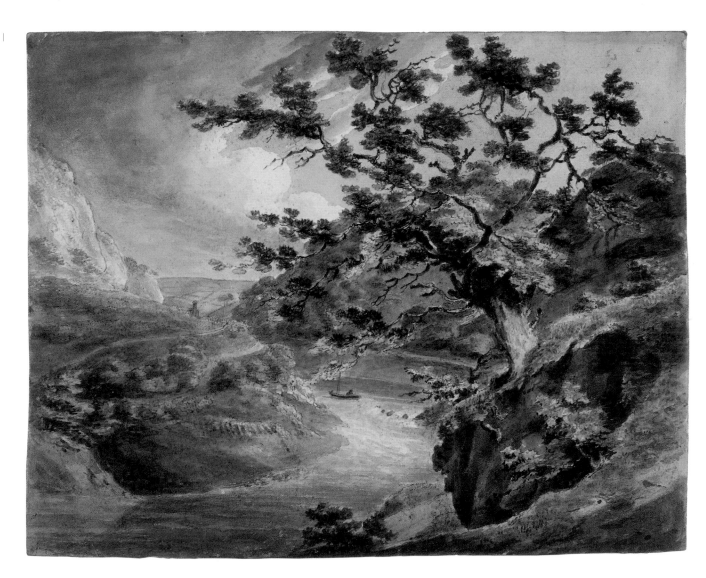

The Pantheon, Oxford Street, the Morning after the Fire
exh 1792
Pencil and watercolour on paper
51.6 × 64
Bequeathed by the artist 1856
D00121

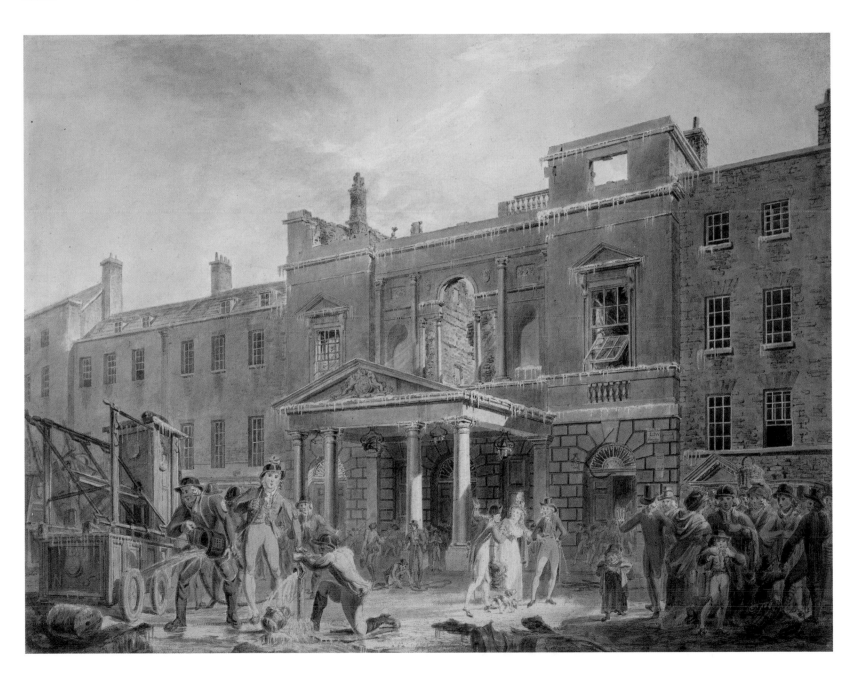

Windmill on Hill: Valley and Winding River in Middle Distance; Sunset Effect
C.1795
Pencil and watercolour on paper
19 × 27.7
Bequeathed by the artist 1856
D00670

Internal of a Cottage: a Study at Ely
exh 1796
Pencil and watercolour on paper
20.4 × 27
Bequeathed by the artist 1856
D00729

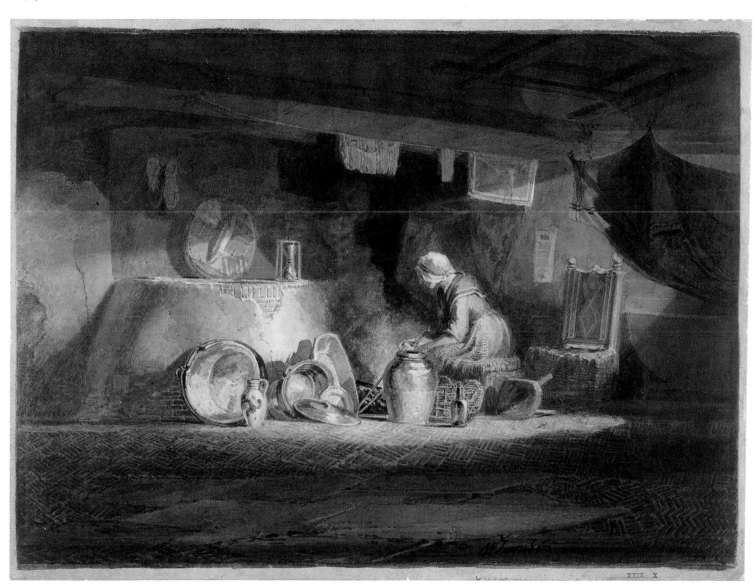

Moonlight over the Sea at Brighton
c.1796–7
Gouache and watercolour on paper
13.3 × 20.9
Bequeathed by the artist 1856
D00885

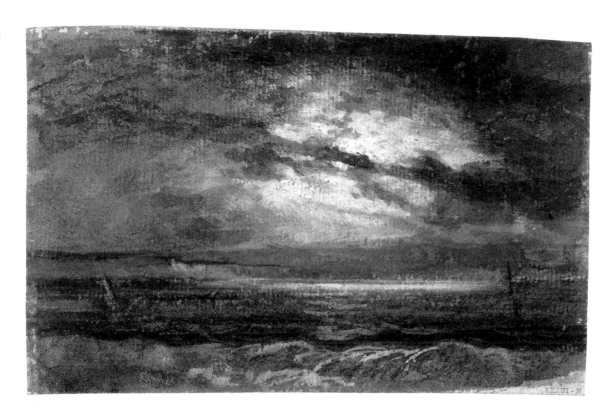

Norham Castle, Sunrise: Colour Study
1797–8
Pencil and watercolour on paper
56 × 76.5
Bequeathed by the artist 1856
D02343

Richmond, Yorkshire, Sunrise: Colour Study
c.1799
Pencil and watercolour on paper
42.3 × 54.9
Bequeathed by the artist 1856
D01116

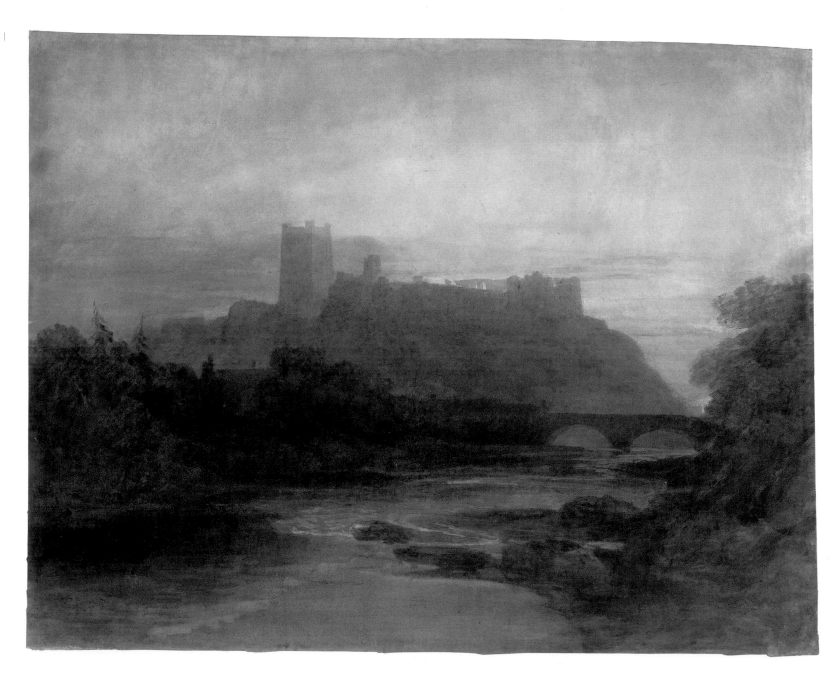

**The Interior of Durham Cathedral,
Looking East along the South Aisle**
c.1798
Pencil, watercolour and gouache on paper
75.8 × 58
Bequeathed by the artist 1856
DO1101

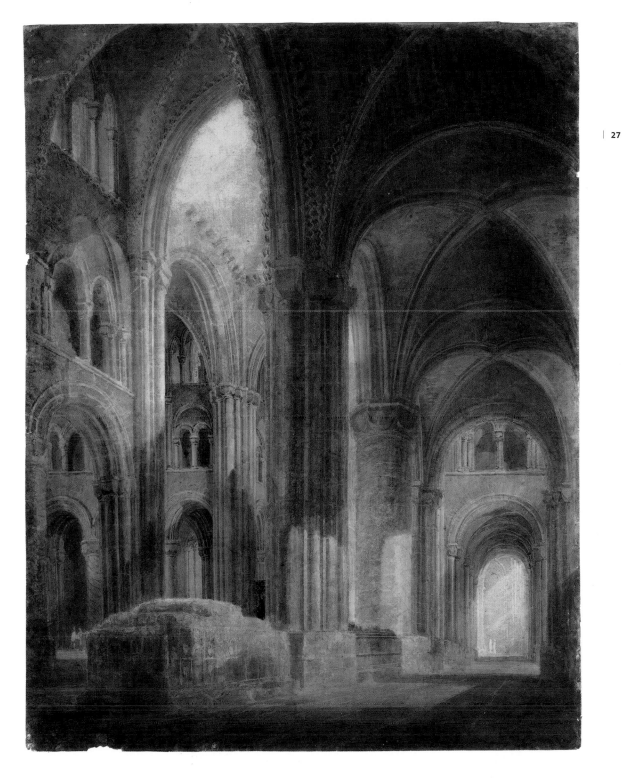

**View over the Lake at Stourhead; Watermill on Right;
Figures with Plough and Carts in Foreground**
?1798
Pencil and watercolour on paper
52.8 × 68.1
Bequeathed by the artist 1856
D01909

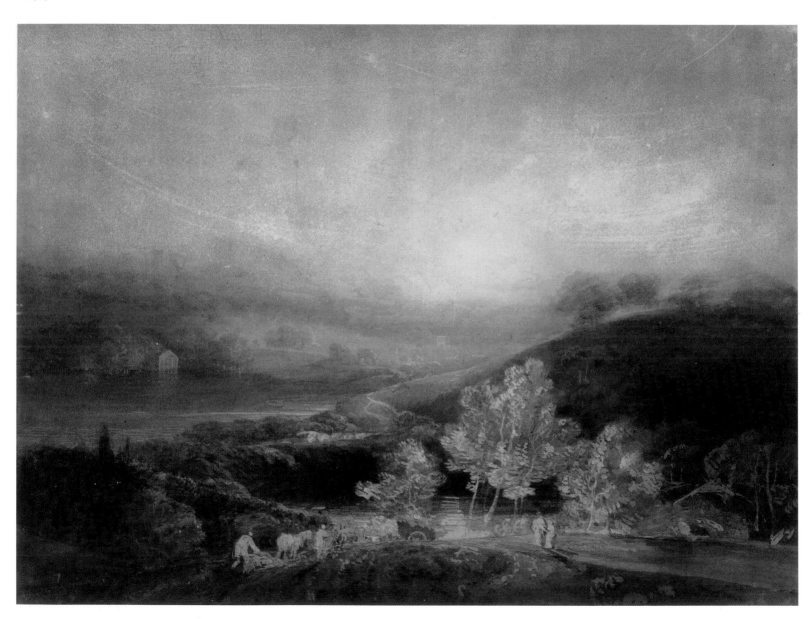

View of Fonthill Abbey
1799–1800
Pencil and watercolour on paper
104.5 × 71.2
Bequeathed by the artist 1856
D04167

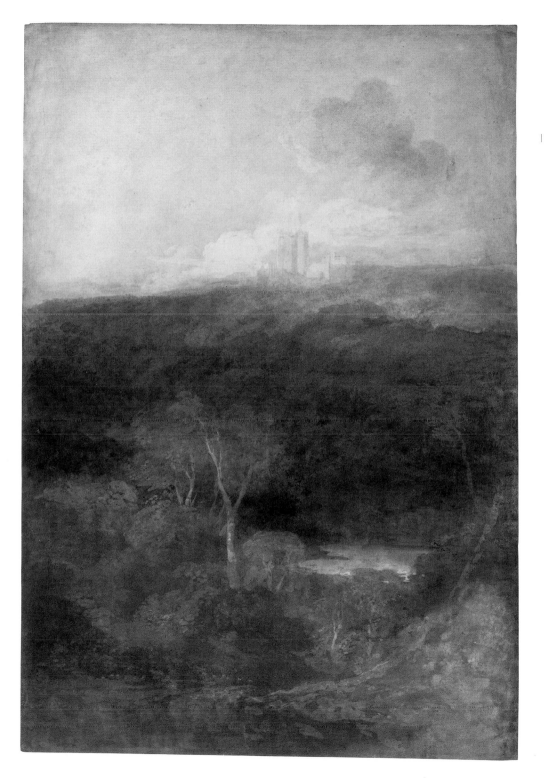

Caernarvon Castle, North Wales
exh 1800
Watercolour on paper
70.6 × 105.5
Bequeathed by the artist 1856
D04164

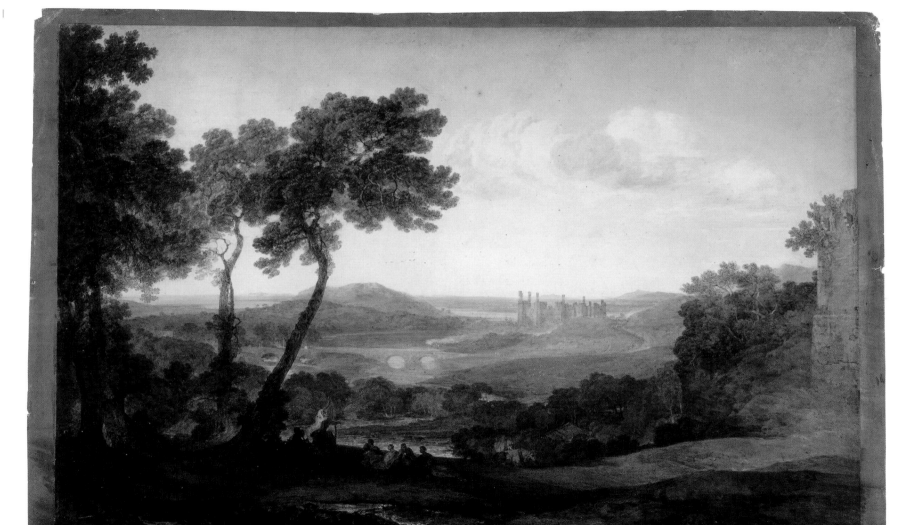

**A Bard and Other Figures, with a Crowd of Dancers,
in a Landscape with Distant Mountains**
1799–1800
Watercolour on paper
54.7 × 74.7
Bequeathed by the artist 1856
D04165

**Looking down a Deep Valley towards Snowdon,
with an Army on the March**
1799–1800
Gouache and watercolour on paper
68.6 × 100
Bequeathed by the artist 1856
D04168

The Siege of Seringapatam
c.1800
Watercolour, body colour and pencil on paper
42.1 × 65.4
Purchased 1986
T04160

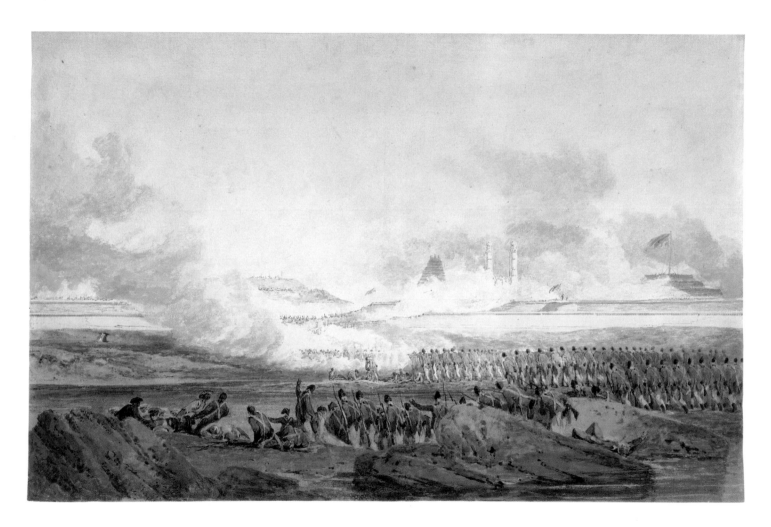

Blair Atholl, Looking towards Killiecrankie
c.1801
Watercolour and gouache on paper
55.6 × 78.2
Bequeathed by the artist 1856
D04179

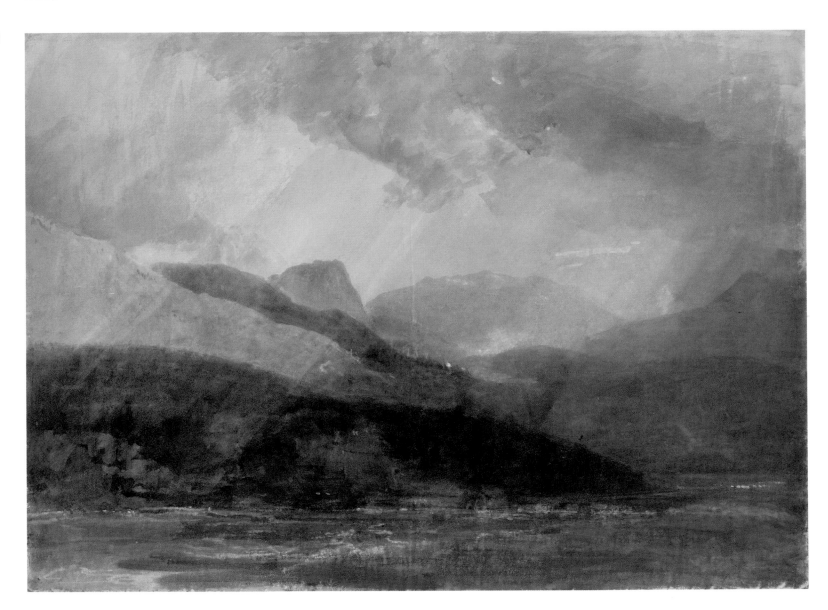

Loch Long, Morning
c.1801–10
Gouache, pencil and watercolour on paper
35.2 × 48.5
Bequeathed by the artist 1856
D03637

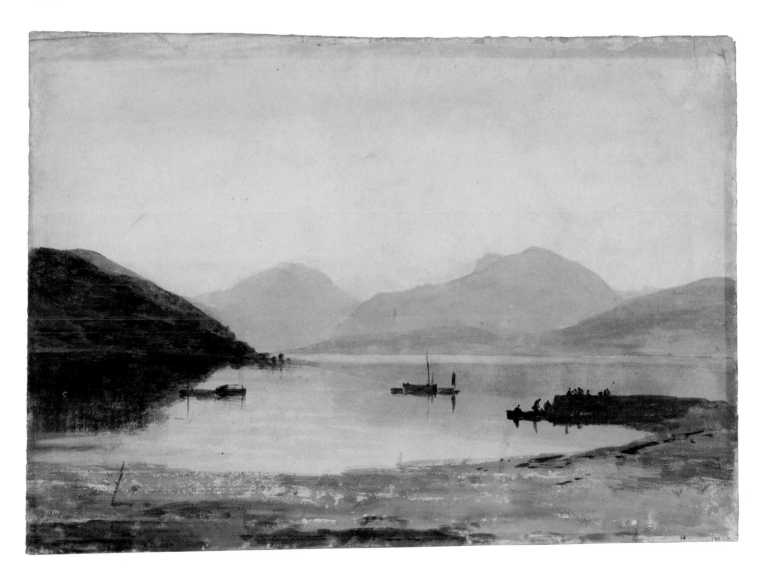

**The St Gotthard Road between Amsteg and
Wassen looking up the Reuss Valley**
c.1803 or 1814–15
Gouache, pencil and watercolour on paper
67.5 × 101
Bequeathed by the artist 1856
D04897

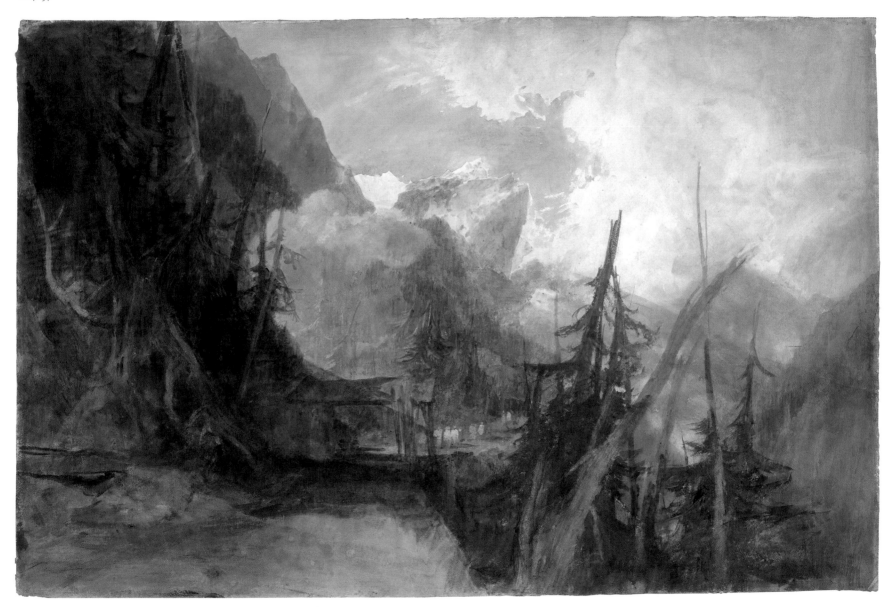

**The Schöllenen Gorge from the Devil's Bridge,
Pass of St Gotthard**
1802
Pencil, watercolour and gouache on paper
47 × 31.4
Bequeathed by the artist 1856
D04625

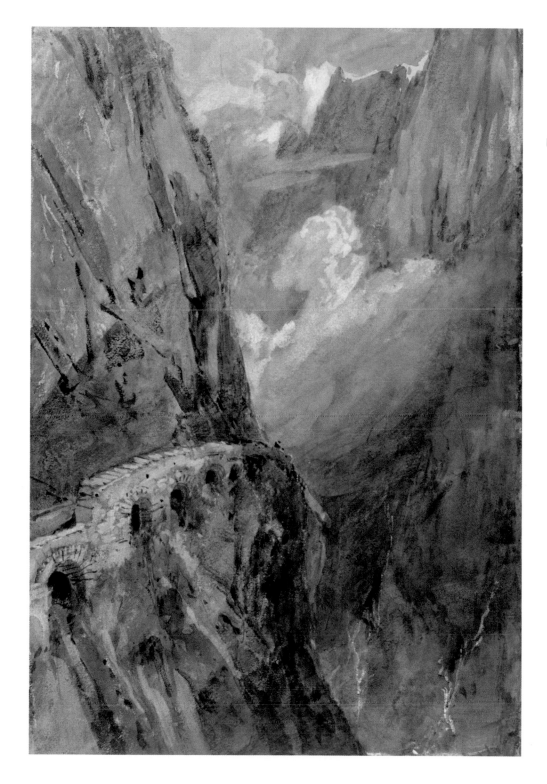

Nature and the Ideal
England c.1805–15

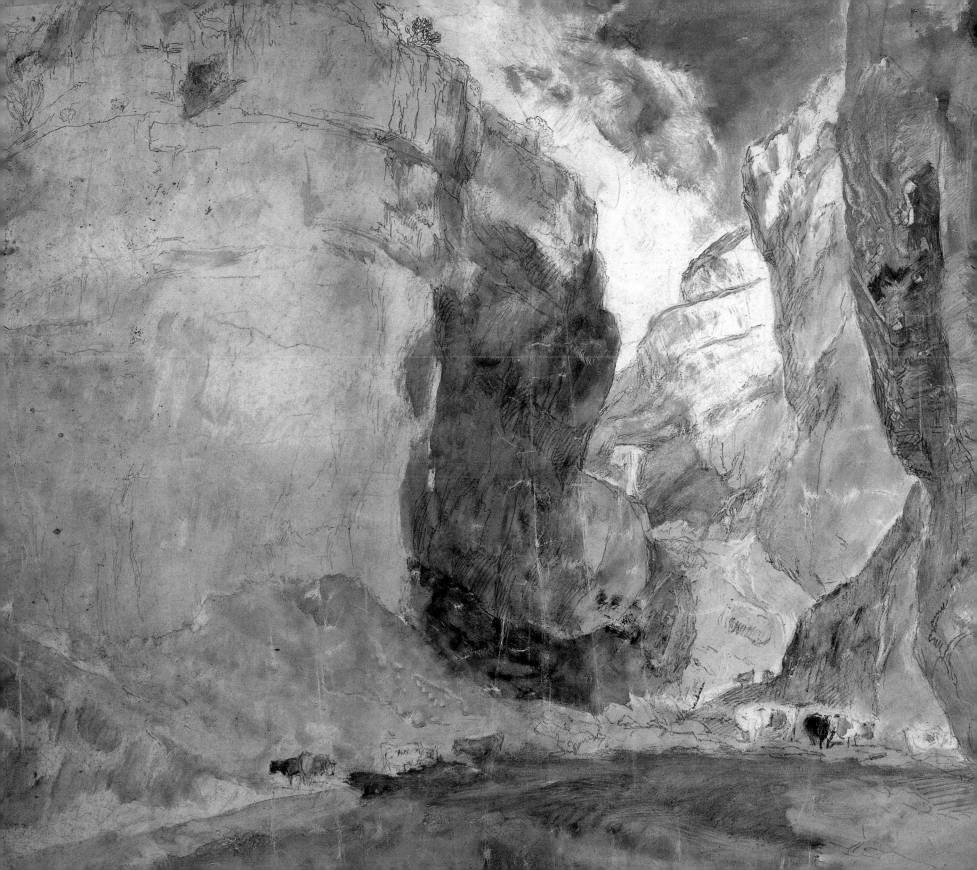

Syon House and Kew Palace from near Isleworth
('The Swan's Nest')
1805
Watercolour on paper
68.4 × 101.3
Bequeathed by the artist 1856
D04163

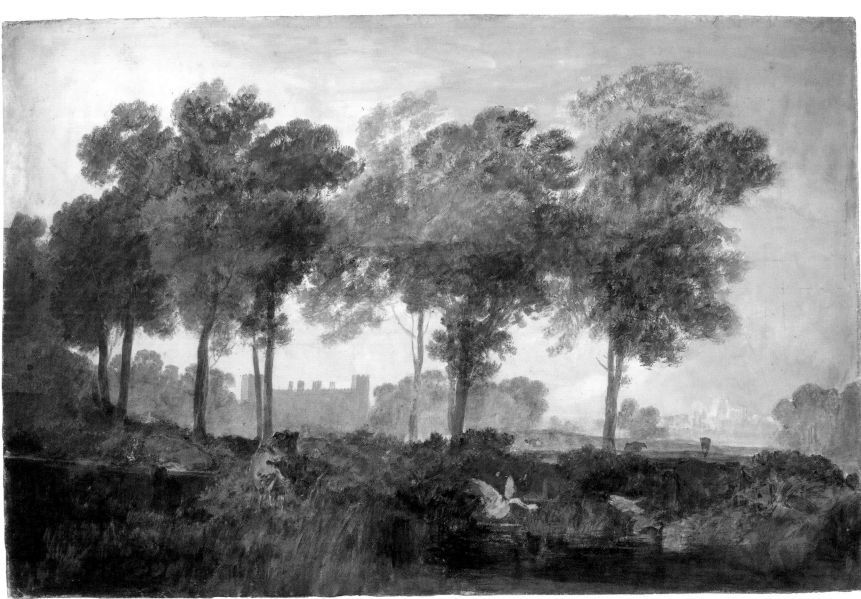

The Ford
c.1805
Gouache, pencil and watercolour on paper
54.5 × 75.9
Bequeathed by the artist 1856
D04162

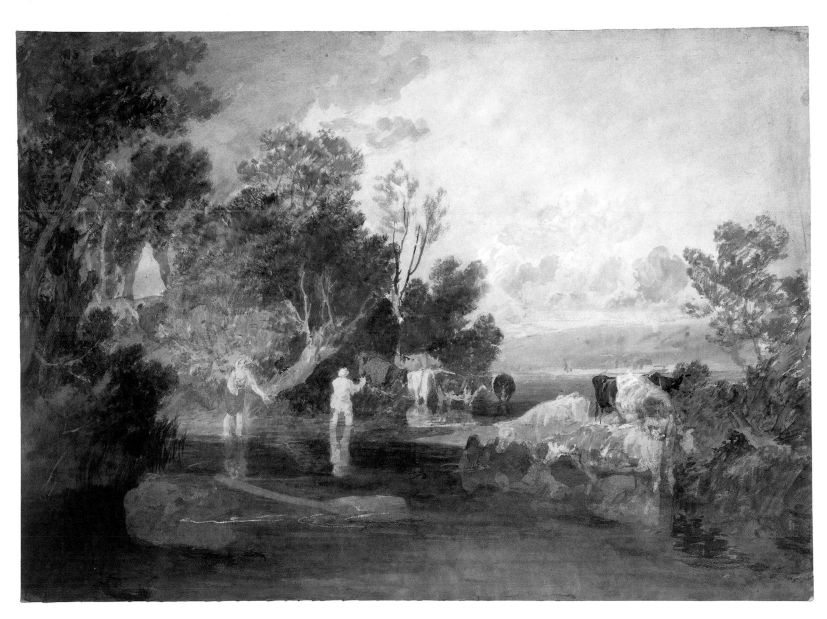

from Thames, from Reading to Walton Sketchbook
Thames near Isleworth; Punt in the Foreground
1805
Pencil and watercolour on paper
25.8 × 36.5
Bequeathed by the artist 1856
D05953

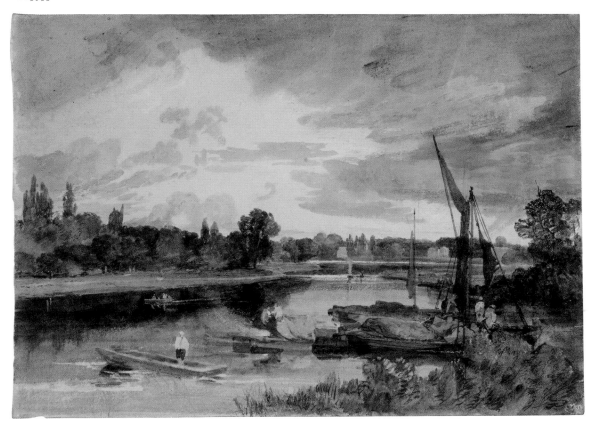

from Thames, from Reading to Walton Sketchbook
Kew Bridge, with Brentford Eyot in the Foreground and
Strand-on-Green Seen through the Arches: Low Tide
1805
Pencil and watercolour on paper
25.6 × 36.4
Bequeathed by the artist 1856
D05946

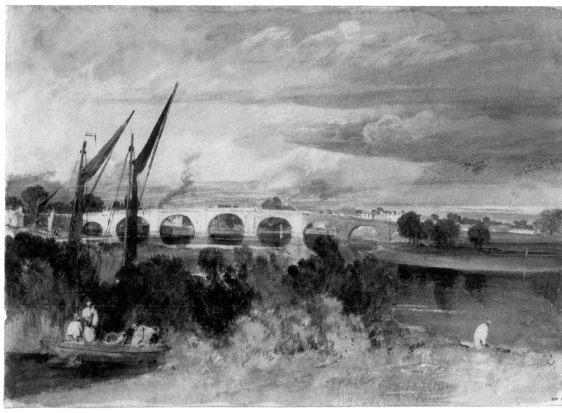

**Interior of the Great Room at Somerset House,
Lecture Diagram 26**
c.1810
Pencil and watercolour on paper
66.9 × 100
Bequeathed by the artist 1856
D17040

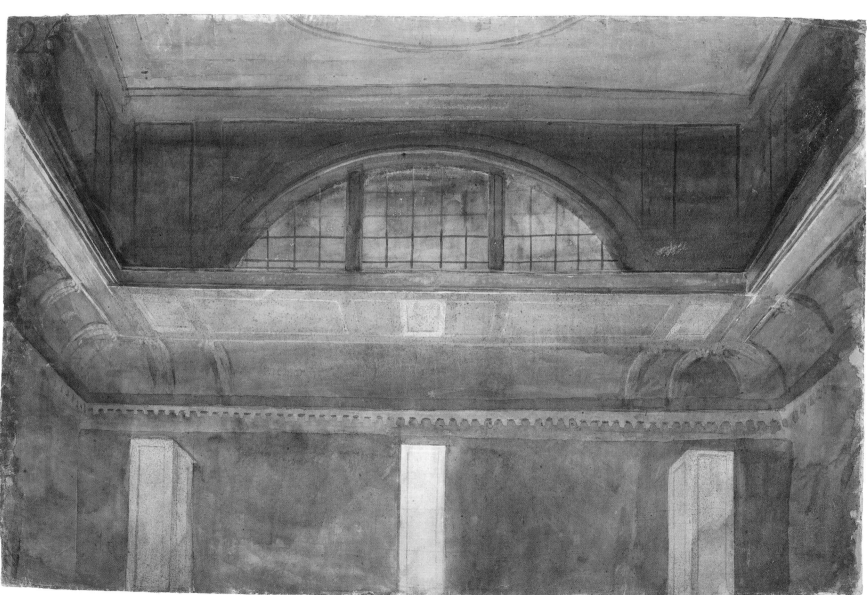

Interior of a Prison, Lecture Diagram 65
c.1810
Gouache, pencil and watercolour on paper
48.7 × 68.7
Bequeathed by the artist 1856
D17090

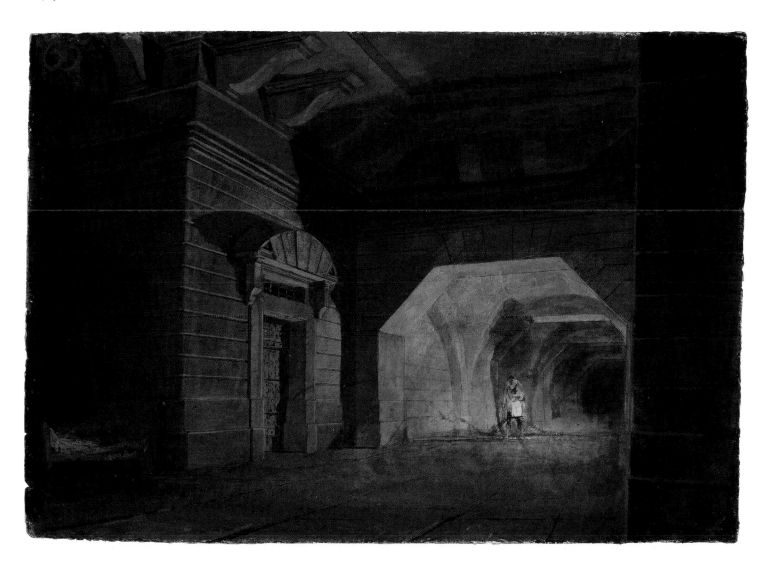

Bridge and Goats, for the 'Liber Studiorum'
c.1806–7
Etching and watercolour on paper
18 × 25
Bequeathed by the artist 1856
D08147

The Fifth Plague of Egypt, for the 'Liber Studiorum'
c.1806–7
Watercolour on paper
18 × 25.3
Bequeathed by Henry Vaughan 1900
D08120

Mill near the Grand Chartreuse, for the 'Liber Studiorum'
c.1812–15
Watercolour on paper
23.2 × 34.2
Bequeathed by Henry Vaughan 1900
D08156

Holy Island Cathedral, for the 'Liber Studiorum'
c.1806–7
Watercolour on paper
18.5 × 26.5
Bequeathed by the artist 1856
D08115

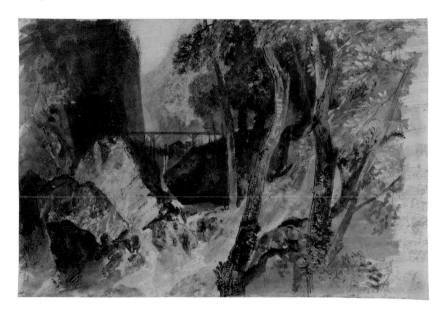

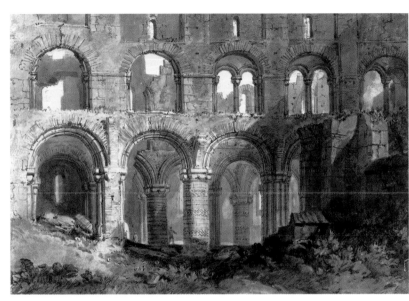

Hulks on the Tamar: Twilight
c.1813
Gouache and watercolour on paper
26.2 × 33
Bequeathed by the artist 1856
D17169

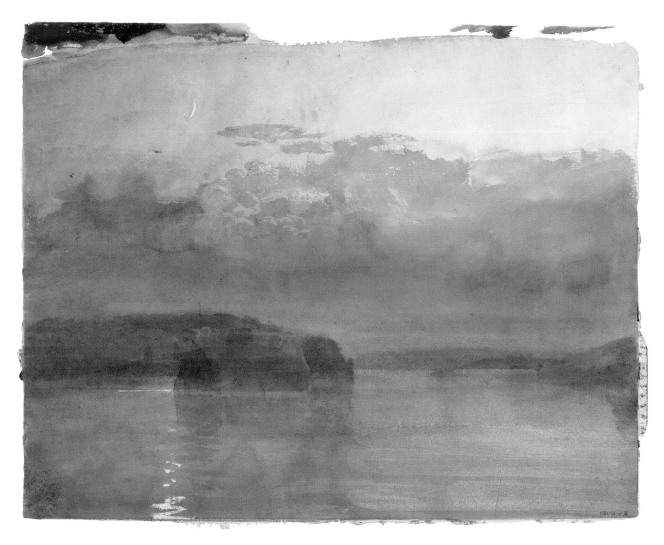

Bren Tor and the Lydford Valley, Devonshire
?1813–16
Watercolour on paper
17.3 × 24.5
Bequeathed by the artist 1856
D25436

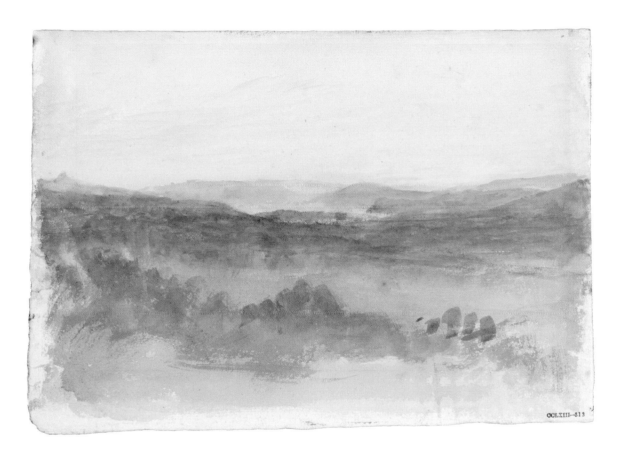

CCLXIII–313

?Study for 'Eddystone Lighthouse'
c.1817
Pencil and watercolour on paper
25.4 × 38.3
Bequeathed by the artist 1856
D17172

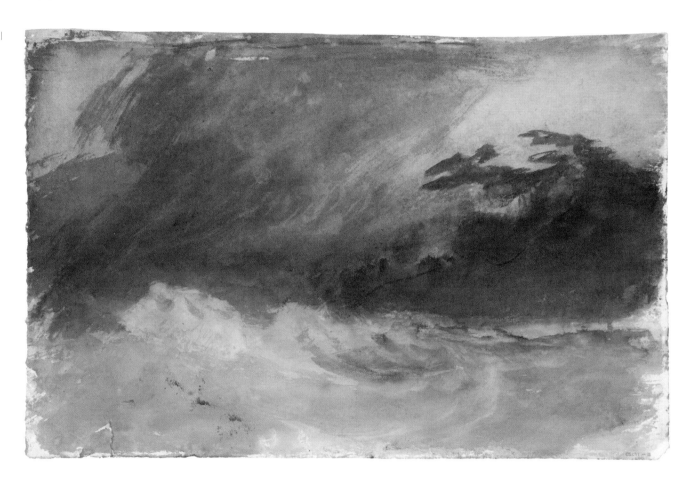

Beginning for 'Loss of an East Indiaman'
c.1818
Pencil, watercolour and chalk on paper
31.1 × 46
Bequeathed by the artist 1856
D17178

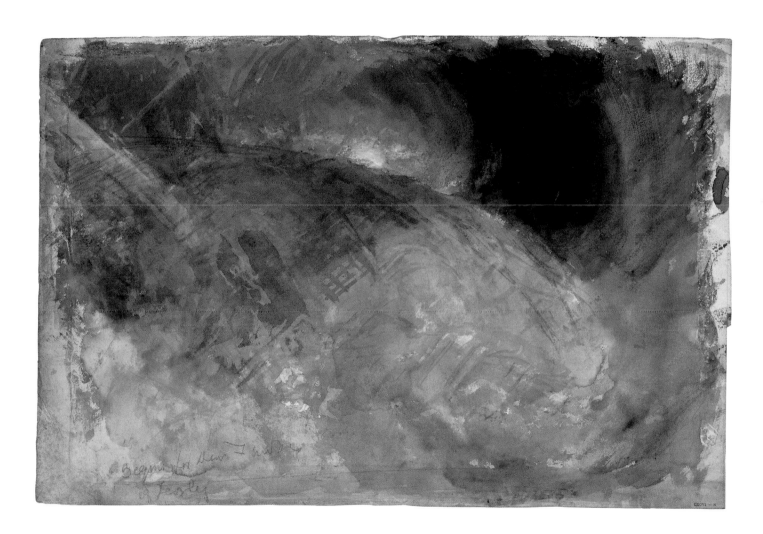

Colour Study of Mill Gill Fall, near Askrigg, Wensleydale
c.1816
Watercolour on paper
30.2 × 43.4
Bequeathed by the artist 1856
D25255

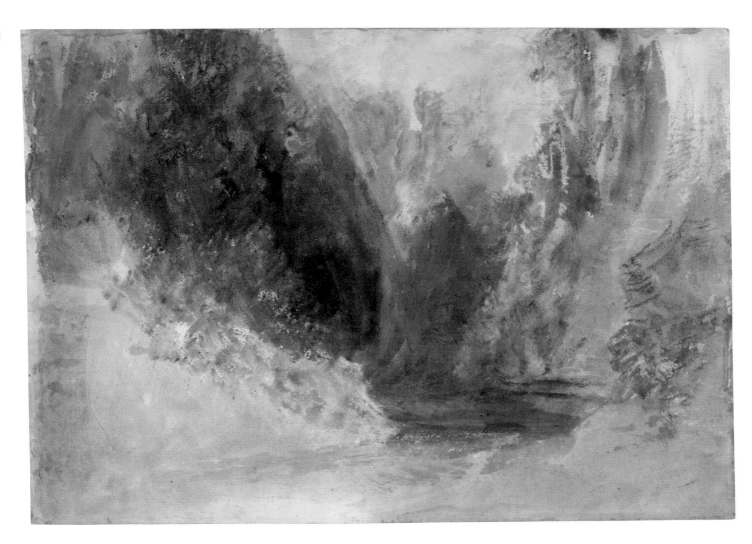

Gordale Scar
c.1816
Mixed media on paper
54.9 × 76.7
Bequeathed by the artist 1856
D12113

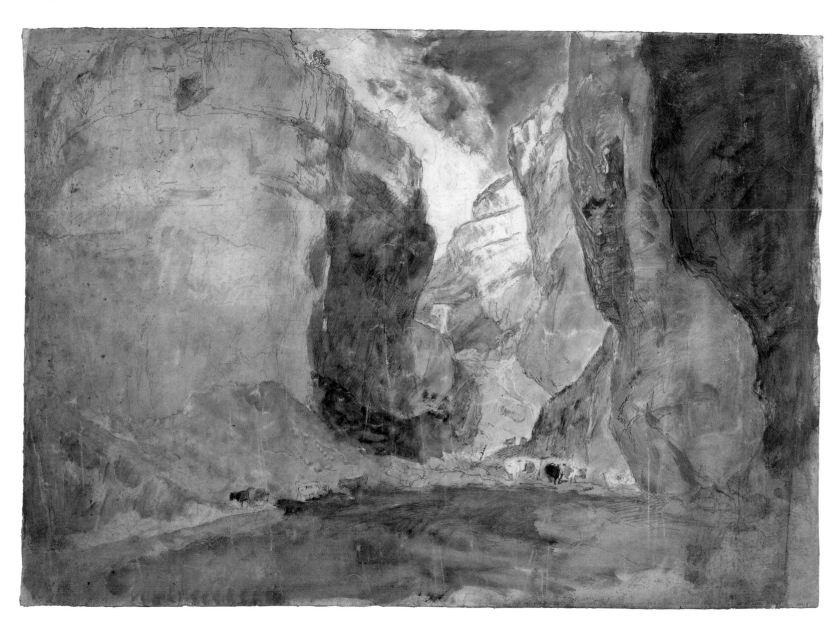

Kirkby Lonsdale: Colour Study
c.1817
Gouache, pencil and watercolour on paper
38.7 × 48.5
Bequeathed by the artist 1856
D17186

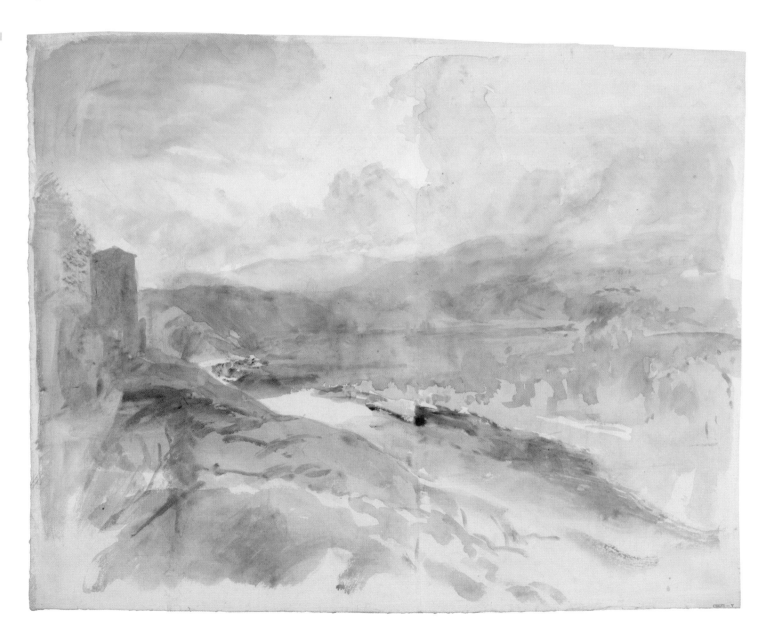

Hylton Castle
c.1817
Gouache and watercolour on paper
30.6 × 48.3
Bequeathed by the artist 1856
D17206

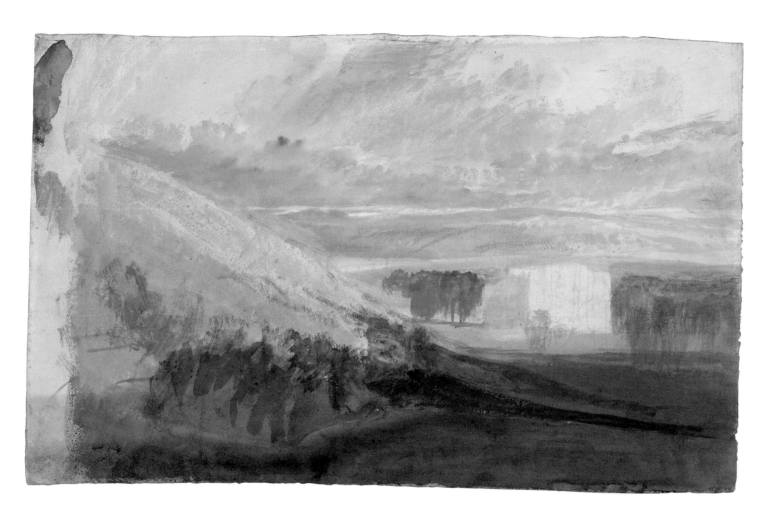

Home and Abroad
1815–30

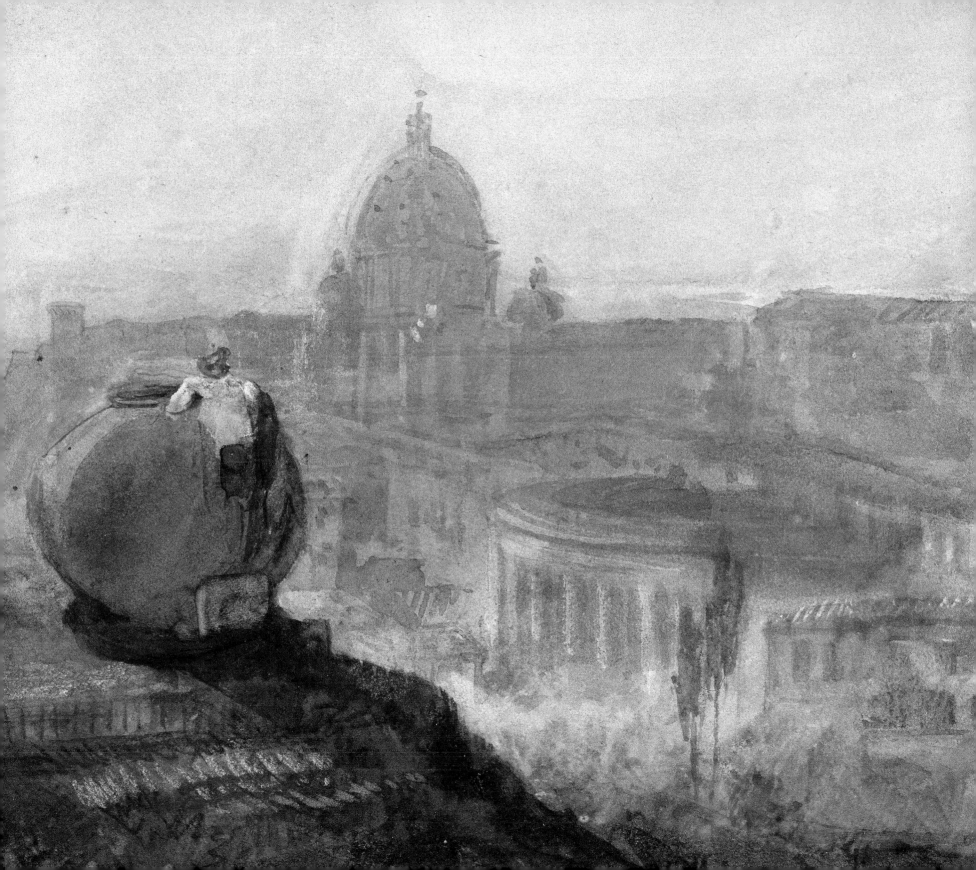

from Como and Venice Sketchbook
Lake Como
1819
Watercolour on paper
22.4 × 29
Bequeathed by the artist 1856
D15251

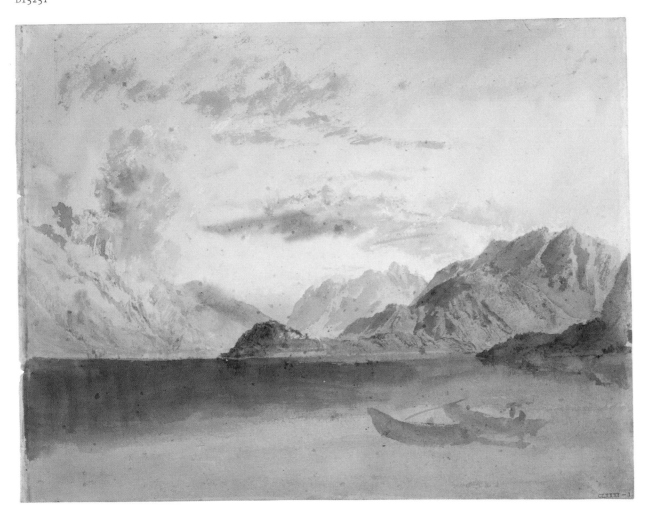

from Como and Venice Sketchbook
Venice: San Giorgio Maggiore – Early Morning
1819
Watercolour on paper
22.3 × 28.7
Bequeathed by the artist 1856
D15254

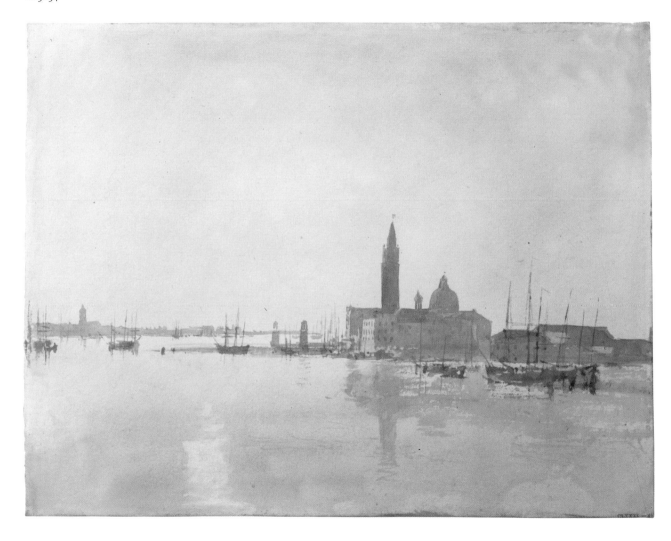

from Rome: Colour Studies Sketchbook
St Peter's from the Villa Barberini
1819
Gouache, pencil and watercolour on paper
23.1 × 37.2
Bequeathed by the artist 1856
D16347

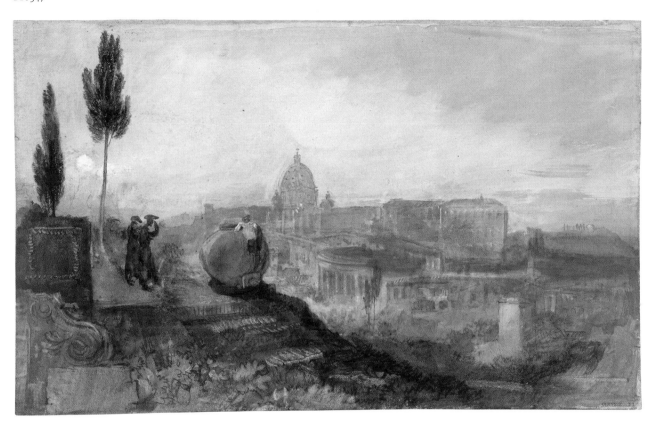

from Rome: Colour Studies Sketchbook
Rome: Arches of Constantine and Titus
1819
Gouache, pencil and watercolour on paper
22.8 × 36.9
Bequeathed by the artist 1856
D16367

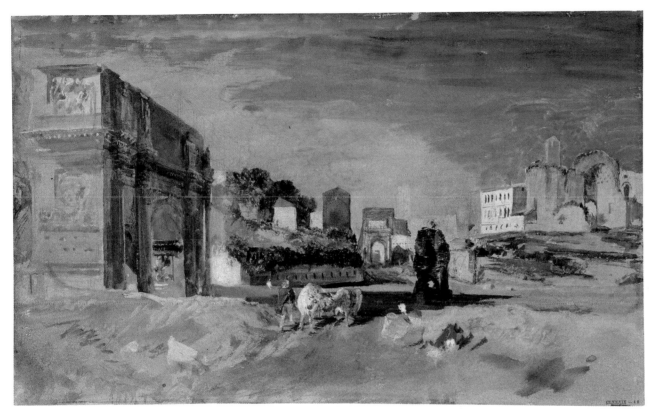

Burg Sooneck with Bacharach in the Distance: Large Colour Study
c.1819–20
Watercolour on paper
40.3 × 56.7
Bequeathed by the artist 1856
D25304

Bridge and Monument

c.1820–5
Pencil and watercolour on paper
18.3 × 27.6
Bequeathed by the artist 1856
D17193

Gloucester Cathedral

c.1826
Watercolour on paper
23 × 30
Bequeathed by the artist 1856
D25430

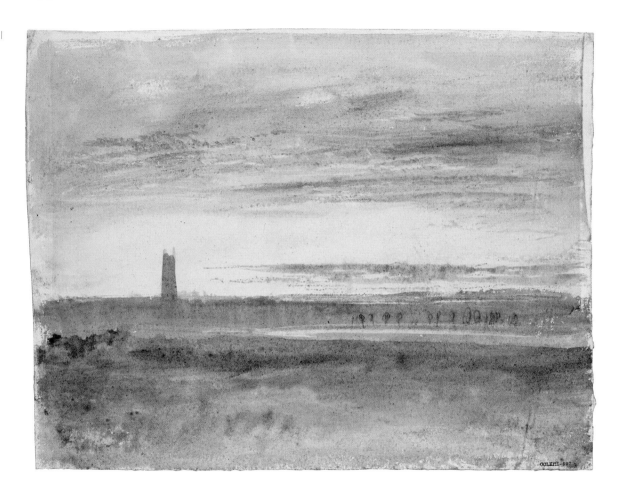

Shields Lighthouse
c.1826
Watercolour on paper
23.4 × 28.3
Bequeathed by the artist 1856
D25431

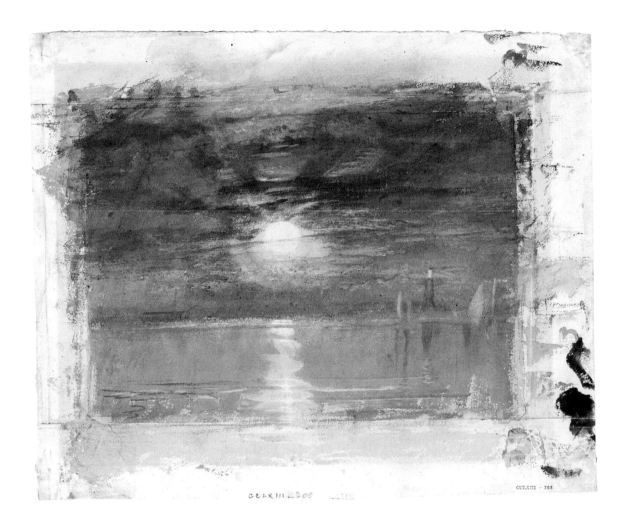

Arundel Castle, on the River Arun
c.1824
Watercolour on paper
15.9 × 22.8
Bequeathed by the artist 1856
D18140

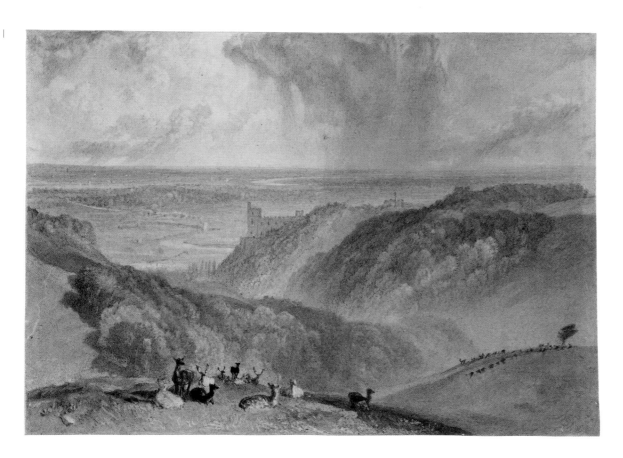

Scarborough
c.1825
Watercolour and pencil on paper
15.7 × 22.5
Bequeathed by the artist 1856
D18142

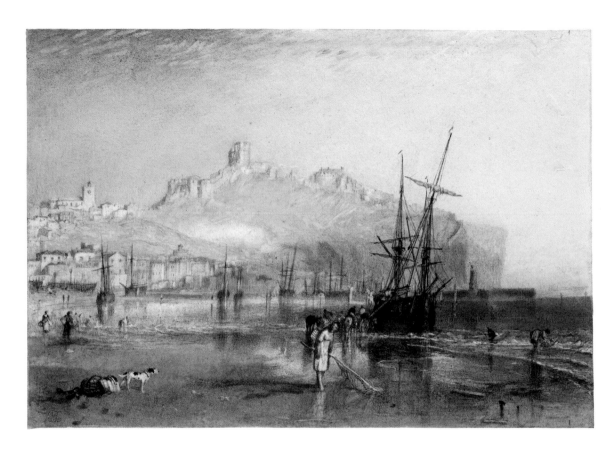

Folkestone from the Sea
1823–4
Watercolour and gouache on paper
48.8 × 68.4
Bequeathed by the artist 1856
D18158

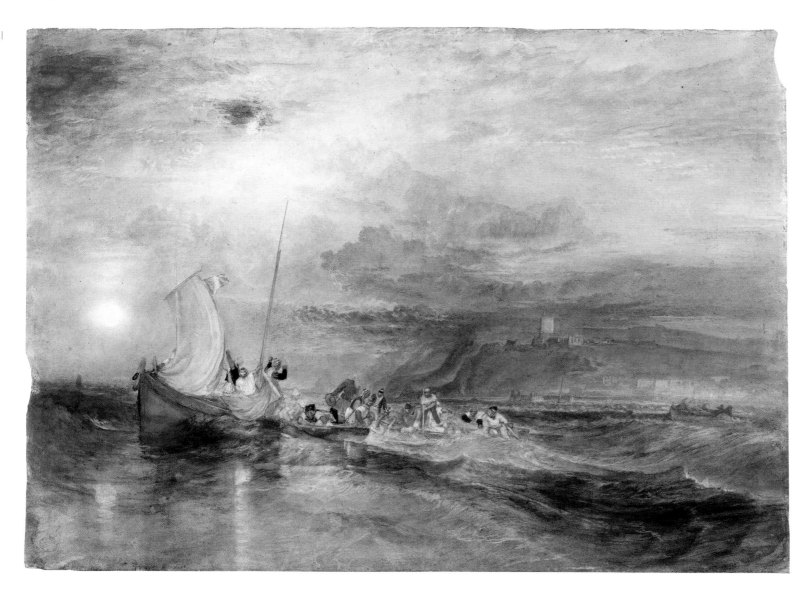

Aldborough, Suffolk
c.1826
Watercolour and bodycolour on paper
28 × 40
Bequeathed by Beresford Rimington Heaton 1940
N05236

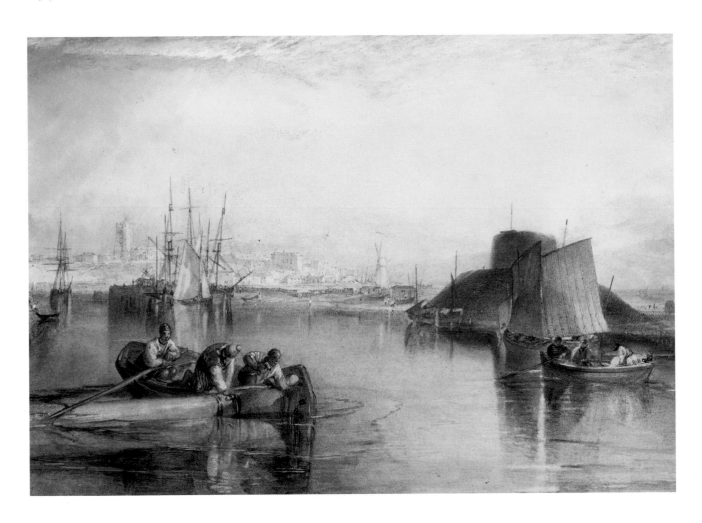

The Northampton Election, 6 December 1830
c.1830–1
Watercolour, gouache and ink on paper
29.2 × 43.8
Purchased 2007
T12321

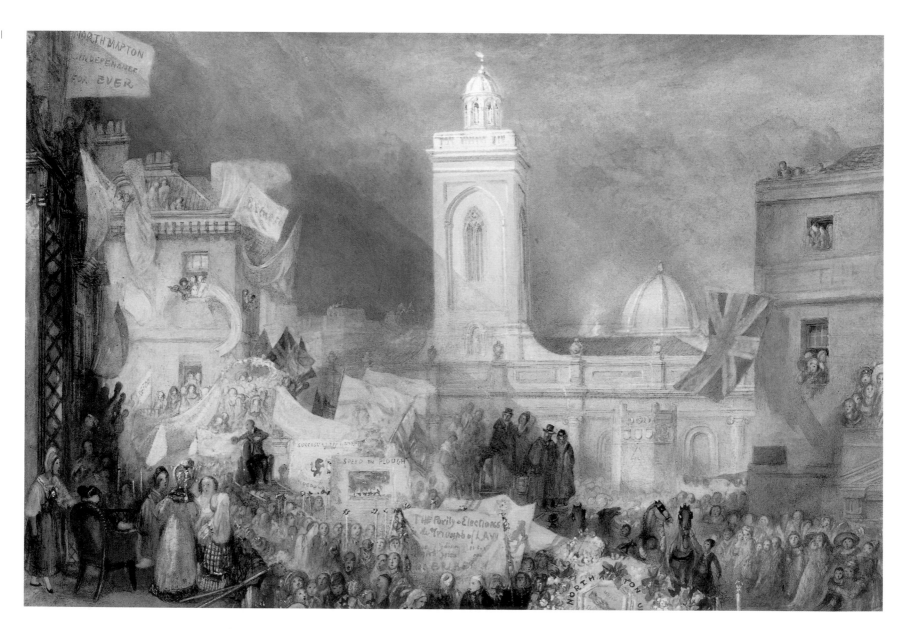

Funeral of Sir Thomas Lawrence: A Sketch from Memory
exh 1830
Watercolour and bodycolour on paper
56.1 × 76.9
Bequeathed by the artist 1856
D25467

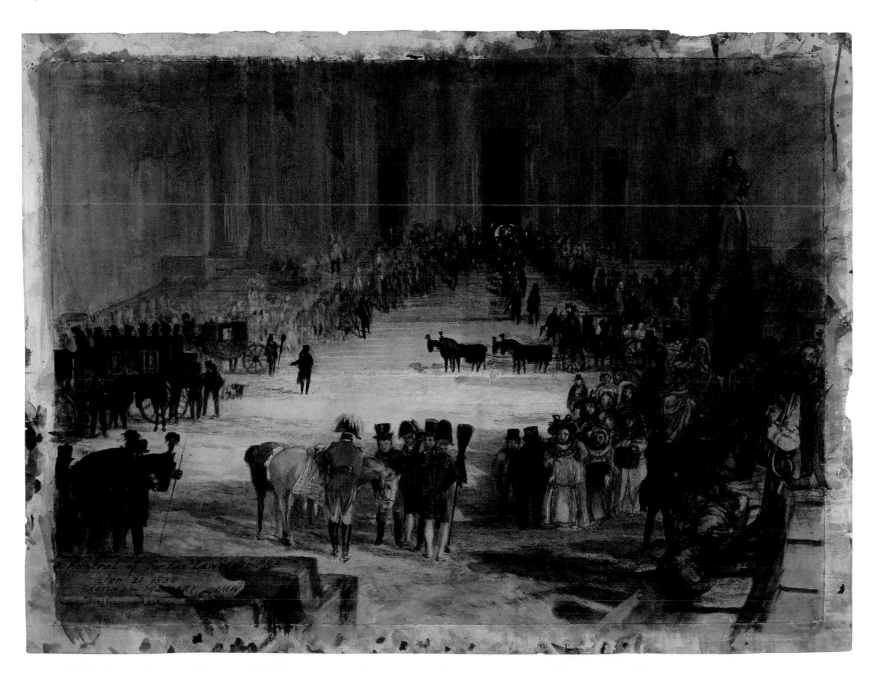

The Artist and his Admirers
1827
Watercolour and bodycolour on paper
13.8 × 19
Bequeathed by the artist 1856
D22764

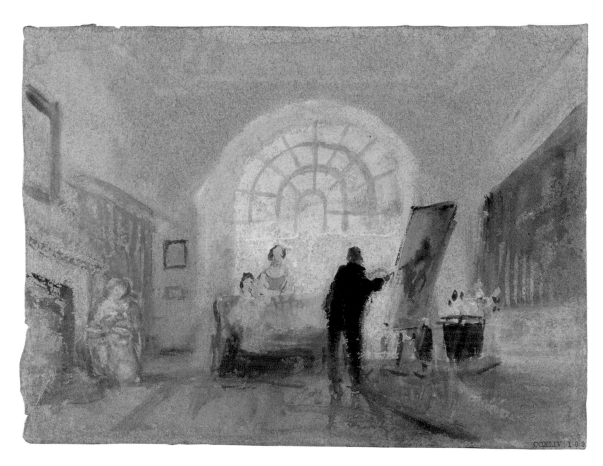

The North Gallery at Night: Figures Contemplating Flaxman's Statue, 'St Michael Overcoming Satan'
1827
Ink, watercolour and bodycolour on paper
14.1 × 19.2
Bequeathed by the artist 1856
D22687

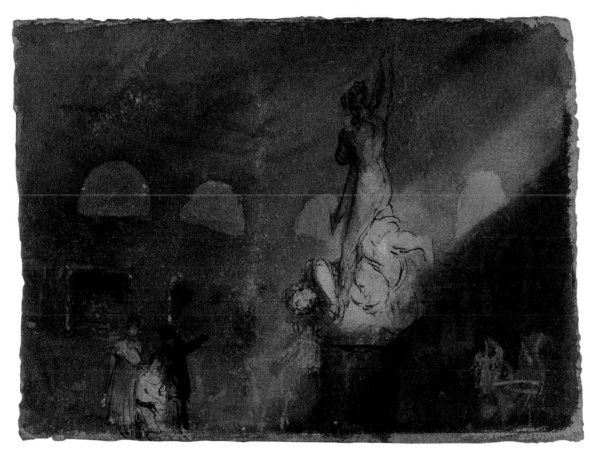

Sunset across the Park from the
Terrace of Petworth House
1827
Gouache and watercolour on paper
14 × 19.3
Bequeathed by the artist 1856
D22664

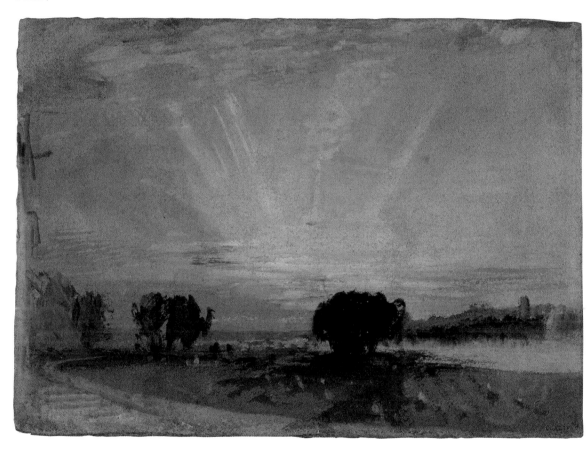

The Somerset Room: Looking into the
Square Dining Room and beyond to the Grand Staircase
1827
Watercolour and bodycolour on paper
13.9 × 18.9
Bequeathed by the artist 1856
D22735

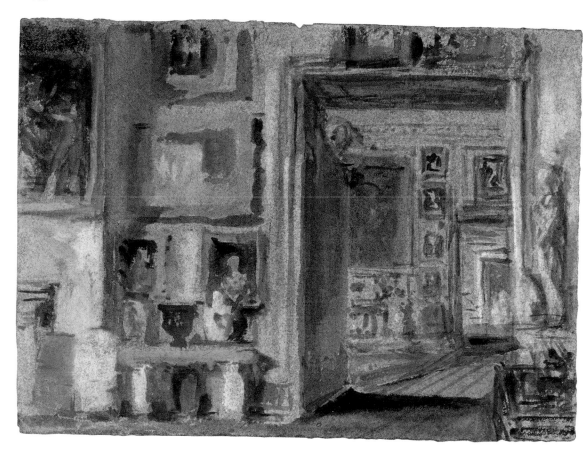

Marengo, for Rogers's `Italy', 1830
c.1826–36
Gouache, pencil and watercolour on paper
21.4 × 29.8
Bequeathed by the artist 1856
D27663

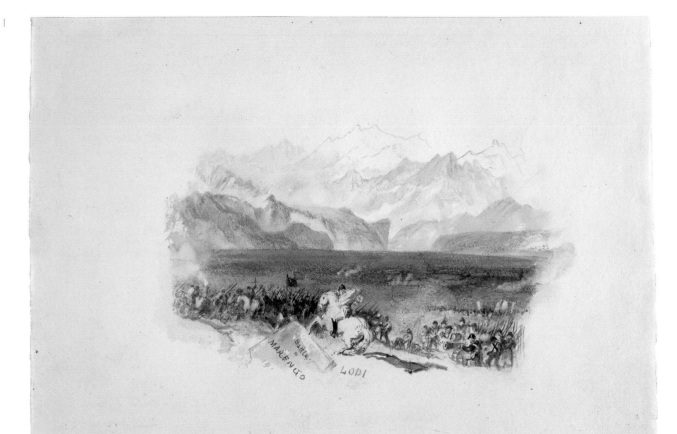

Banditti, for Rogers's 'Italy', 1830
c.1826–36
Pen and ink, pencil and watercolour on paper
24.7 × 30.1
Bequeathed by the artist 1856
D27681

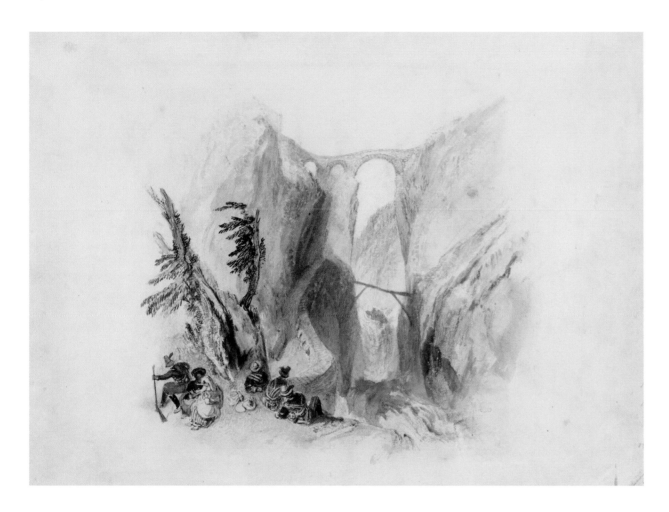

CCLXXX–158

A Villa, Moonlight (A Villa on the Night of a Festa di Ballo), for Rogers's 'Italy', 1830
c.1827
Pen and ink, pencil and watercolour on paper
24.6 × 30.9
Bequeathed by the artist 1856
D27682

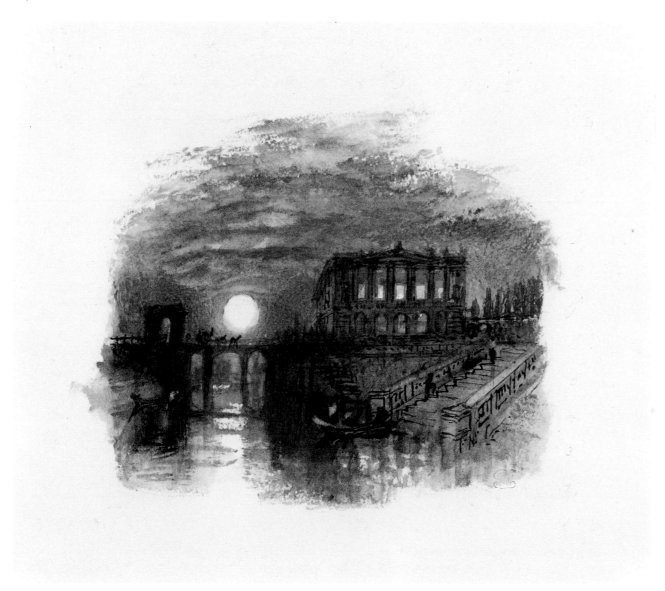

Light and Colour

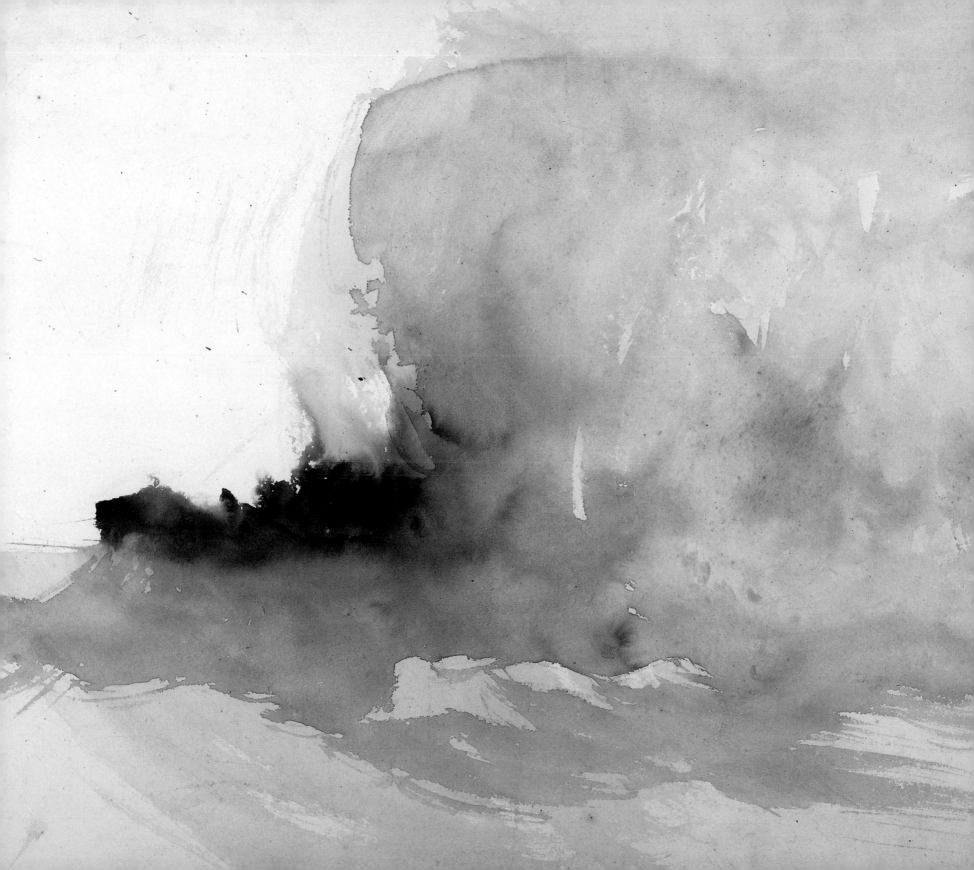

Study of a Classical Landscape: ?Lake Maggiore
c.1828–30
Watercolour on paper
31.2 × 43.9
Bequeathed by the artist 1856
D25311

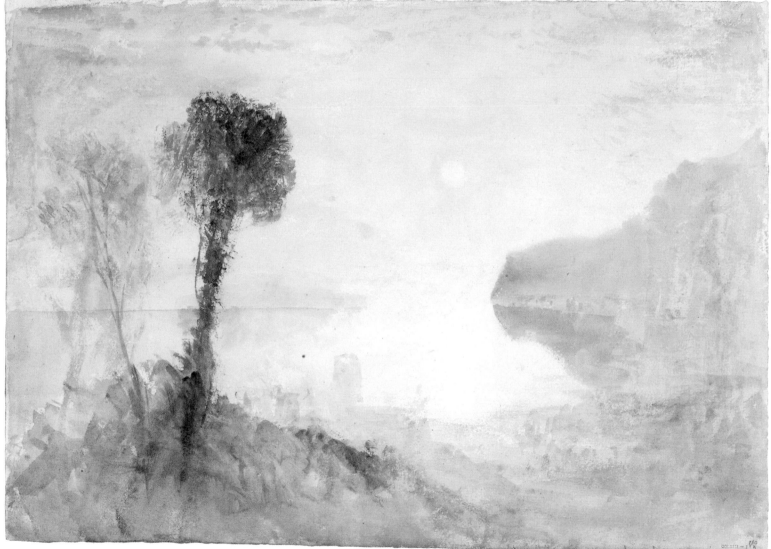

Harlech Castle, Preparatory Study
c.1830–5
Watercolour on paper
30.6 × 48.7
Bequeathed by the artist 1856
D25232

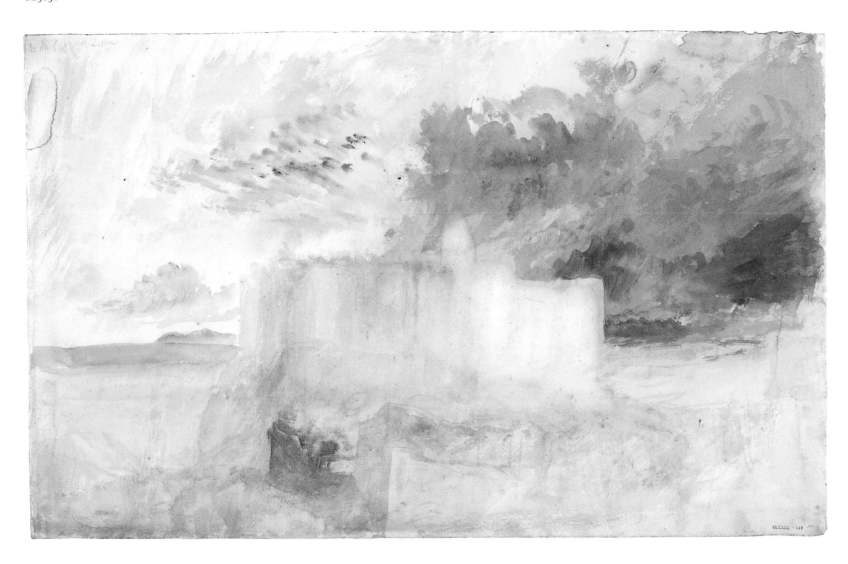

Marly-sur-Seine: Colour Beginning
?1829–30
Watercolour on paper
36.2 × 51.2
Bequeathed by the artist 1856
D25152

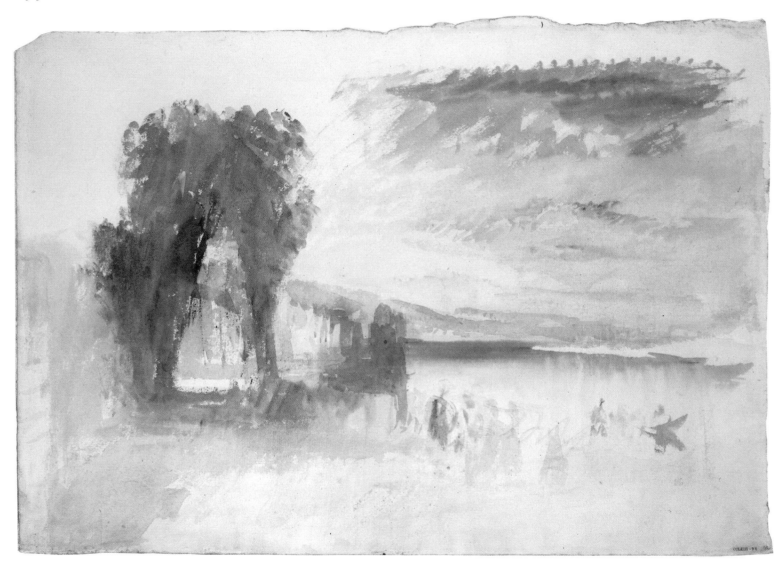

A Mountain Pass
c.1830
Watercolour on paper
30.8 × 49.1
Bequeathed by the artist 1856
D25213

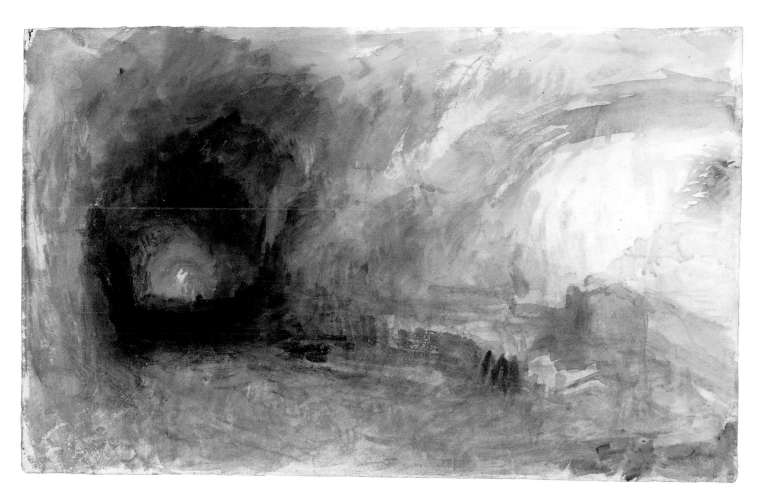

Land's End. Cornwall
?c.1834
Watercolour on paper
35.6 × 31
Bequeathed by the artist 1856
D25129

A Wreck (possibly related to 'Longships Lighthouse, Land's End')
c.1835–40
Watercolour on paper
33.8 × 49.1
Bequeathed by the artist 1856
D25163

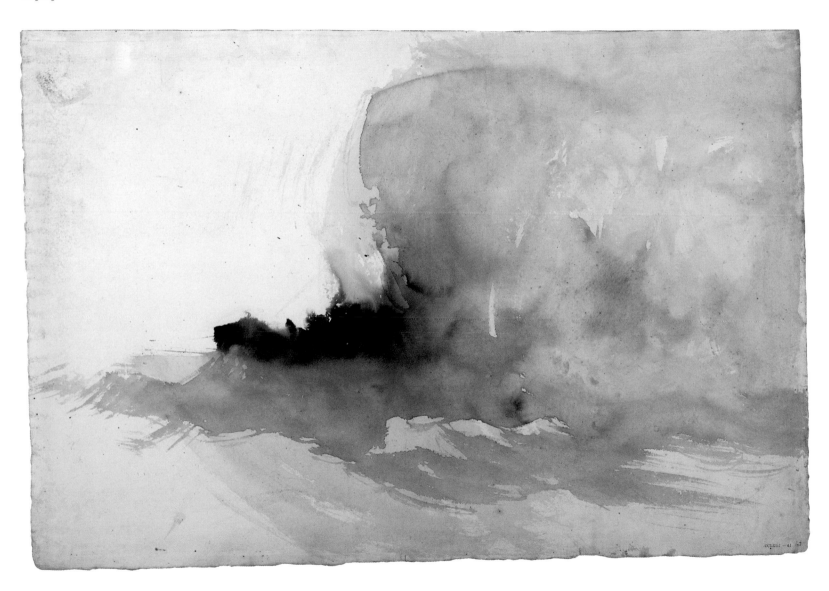

The Annual Tourist
1830–40

Louviers: The High Street with a Diligence
?1827–9
Gouache, pen and ink and pencil on paper
14.1 × 19
Bequeathed by the artist 1856
D24902

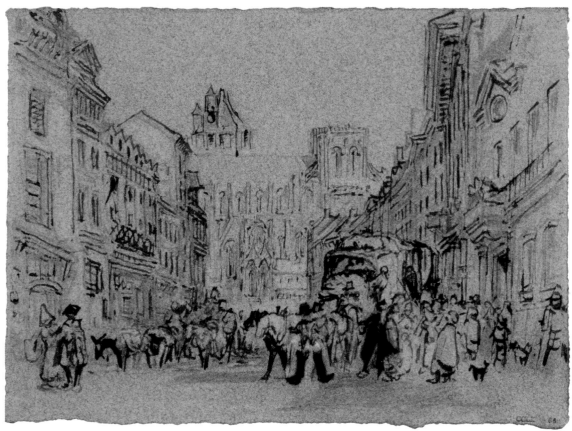

Paris: The Hôtel de Ville and Pont d'Arcole
c.1833
Gouache and watercolour on paper
14.2 × 19.2
Bequeathed by the artist 1856
D24684

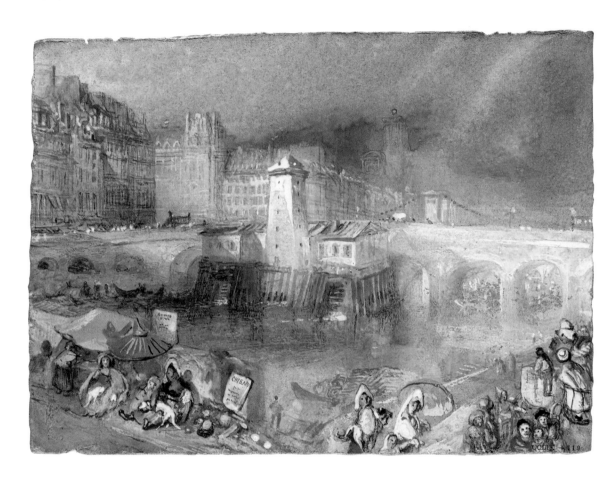

Rouen: the Gros-Horloge, with the Towers of the Cathedral Beyond
c.1832
Gouache and watercolour on paper
14.2 × 19.2
Bequeathed by the artist 1856
D24822

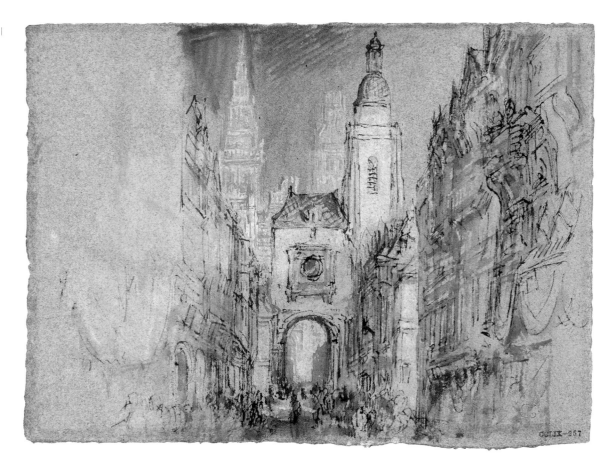

Jumièges
c.1832
Gouache and watercolour on paper
13.9 × 19.1
Bequeathed by the artist 1856
D24696

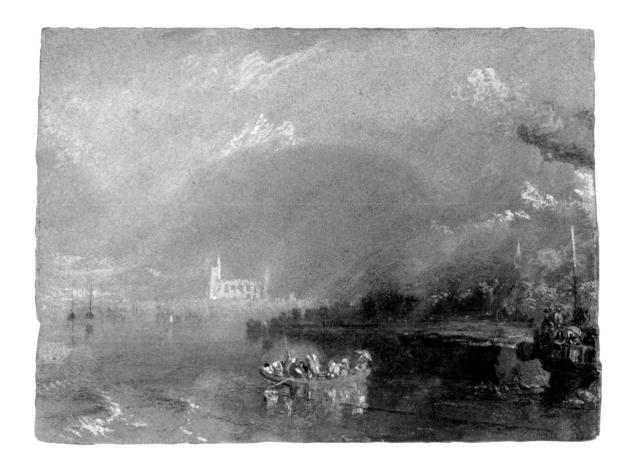

Honfleur from the Water, at Twilight
c.1832
Gouache and watercolour on paper
14 × 19.2
Bequeathed by the artist 1856
D24743

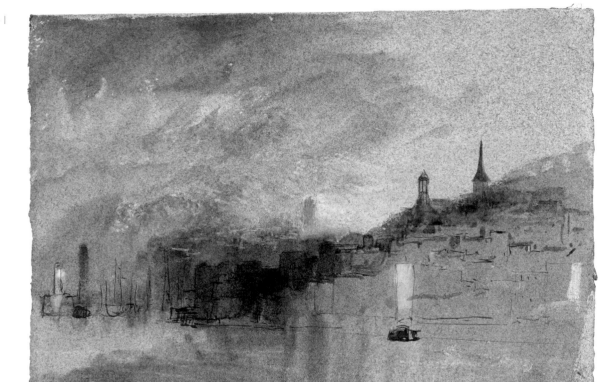

The Leyen Burg at Gondorf
c.1839
Gouache and watercolour on paper
13.8 × 18.8
Bequeathed by the artist 1856
D24588

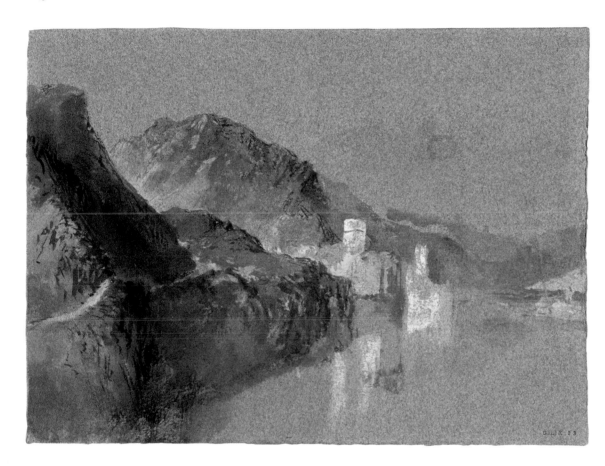

Dinant, Bouvignes and Crèvecoeur: Sunset
c.1839
Gouache and watercolour on paper
13.6 × 18.8
Bequeathed by the artist 1856
D20228

The Pont du Château and the Bock, Luxembourg
c.1839
Gouache, pen and ink and watercolour on paper
14 × 19
Bequeathed by the artist 1856
D20249

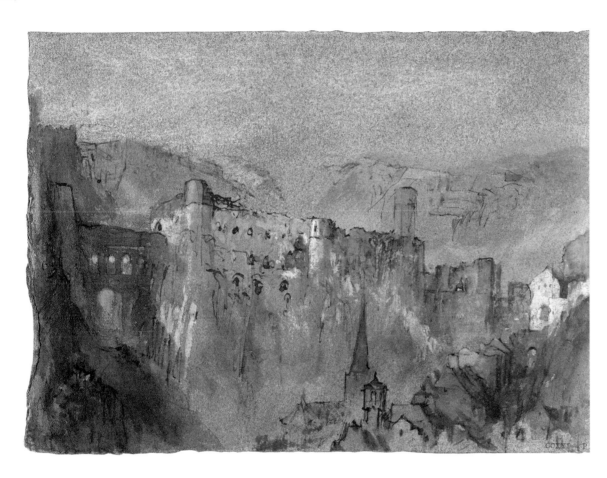

Morteralsch Glacier, Engadine
c.1820–30
Pencil and watercolour on paper
26 × 28
Bequeathed by the artist 1856
D25439

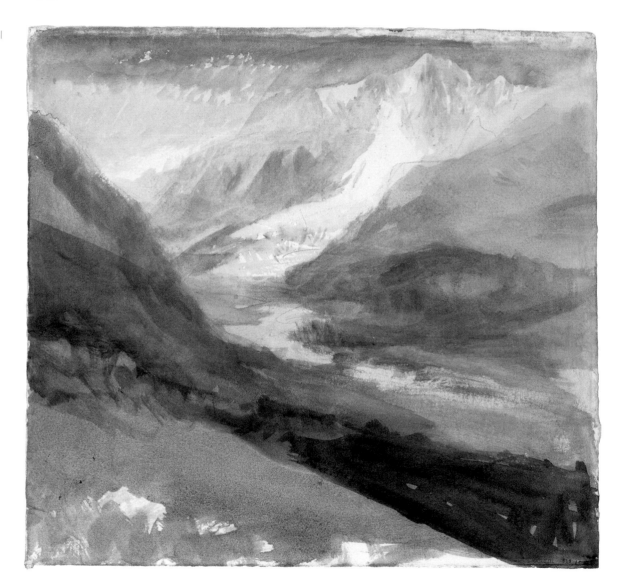

?Mont Blanc, from Brévent
c.1836
Pencil and watercolour on paper
25.6 × 28
Bequeathed by the artist 1856
D35996

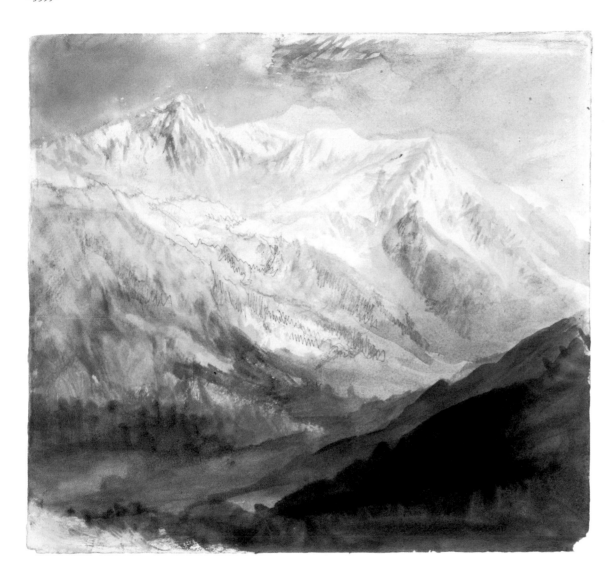

A Vision. Voyage of Columbus, for Rogers's 'Poems'
c.1831–2
Pencil and watercolour on paper
23.2 × 31
Bequeathed by the artist 1856
D27714

The Castle of St Angelo, for Byron's 'Life and Works'
engraved 1832
Watercolour on paper
17.1 × 21
Bequeathed by Beresford Rimington Heaton 1940
N05243

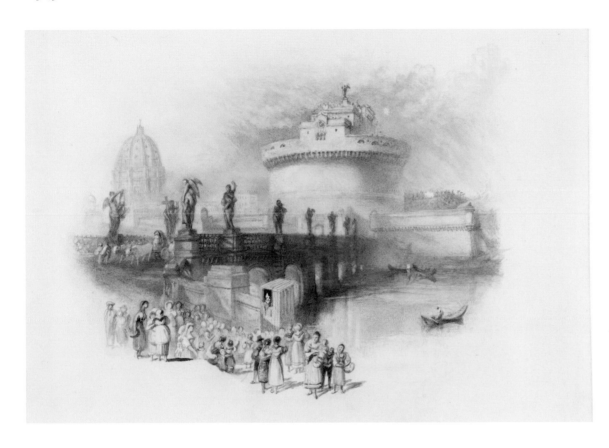

Edinburgh Castle: March of the Highlanders, for Fisher's 'Illustrations to the Waverley Novels'
engraved 1836
Watercolour on paper
8.6 × 14
Bequeathed by R.H. Williamson 1938
NO4953

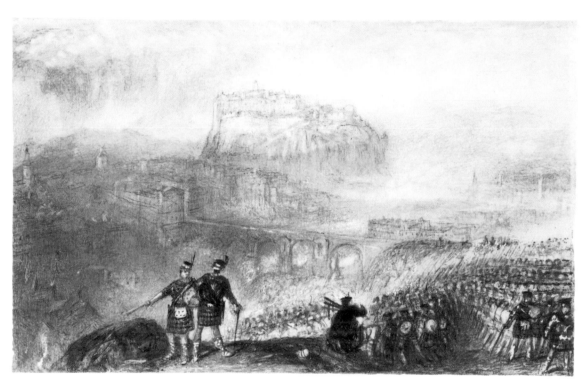

Dryburgh Abbey, for Scott's 'Poetical Works'
c.1832
Watercolour on paper
7.9 × 14.9
Bequeathed by Beresford Rimington Heaton 1940
N05241

Bamburgh Castle, Northumberland: Preparatory Study
c.1837
Watercolour on paper
54.6 × 75.2
Bequeathed by the artist 1856
D25506

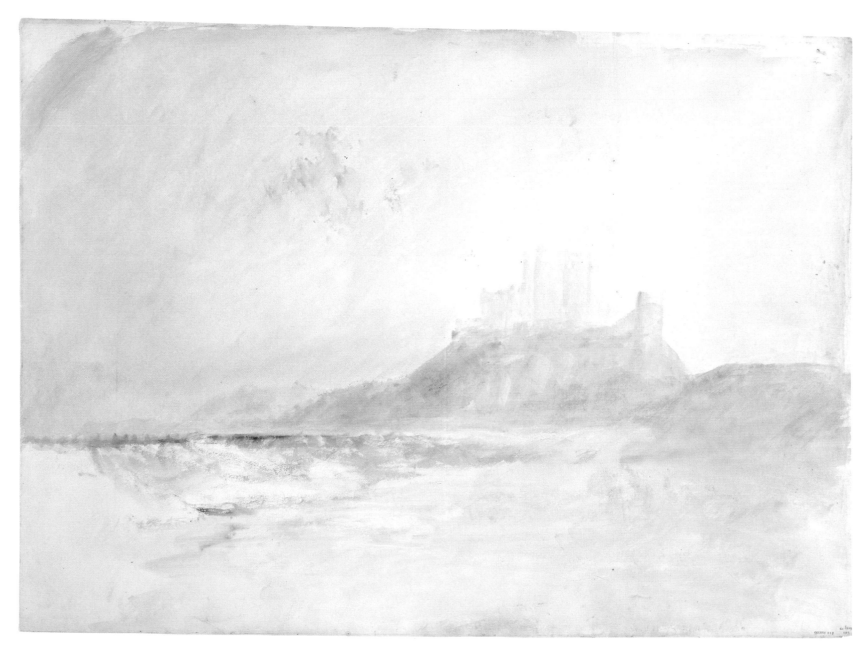

Bamburgh Castle, Northumberland: Preparatory Study
c.1837
Pencil and watercolour on paper
45.9 × 76.9
Bequeathed by the artist 1856
D36321

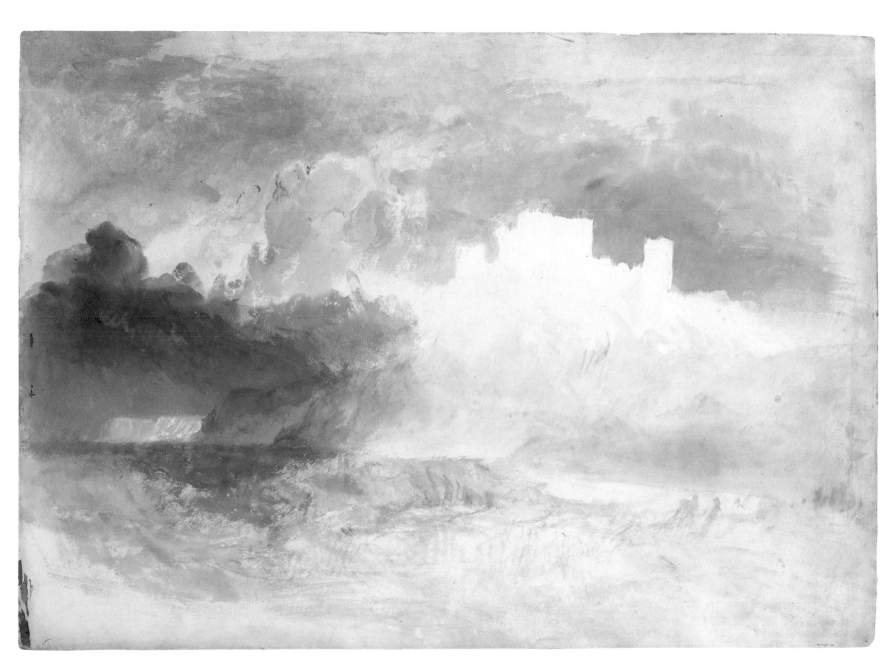

Master and Magician
Late Work

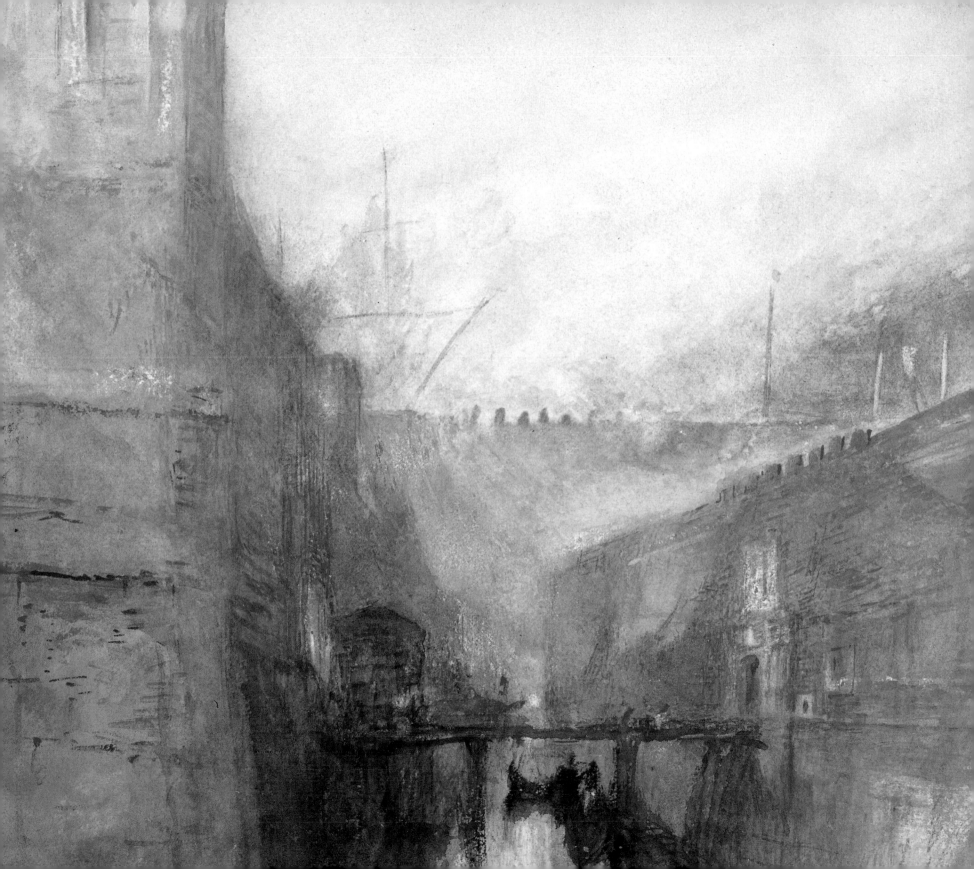

Sunset
after c.1830
Watercolour on paper
24 × 31.5
Bequeathed by the artist 1856
D35990

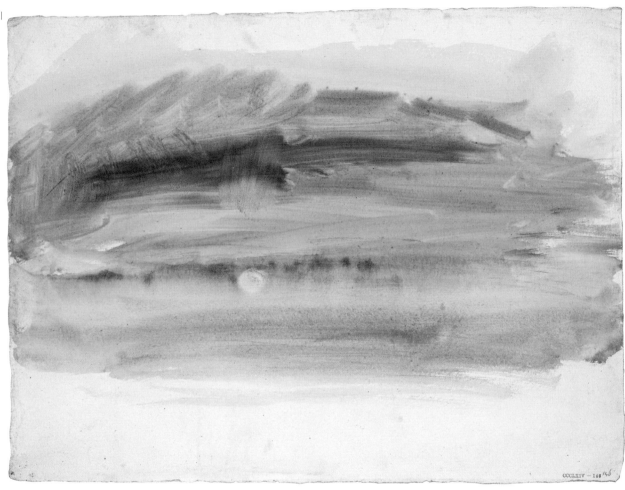

CCCLXIV – 146

Sea and Sky
after c.1830
Watercolour on paper
22.1 × 27.1
Bequeathed by the artist 1856
D36003

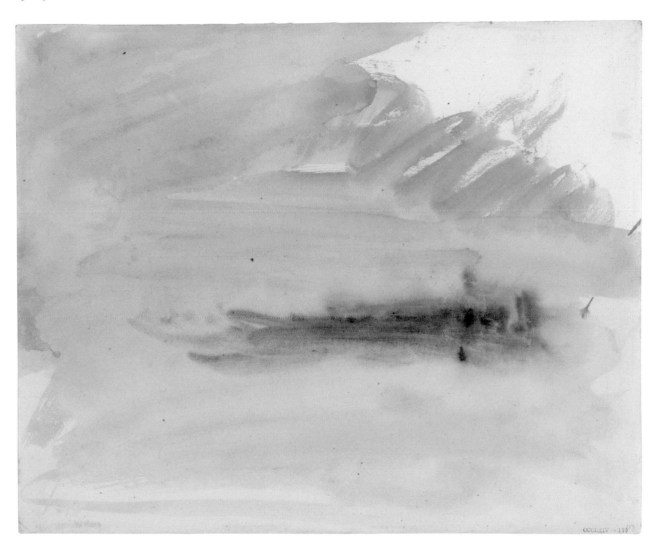

Lake, with the Rigi
after c.1830
Crayon and watercolour on paper
25.3 × 39.3
Bequeathed by the artist 1856
D36075

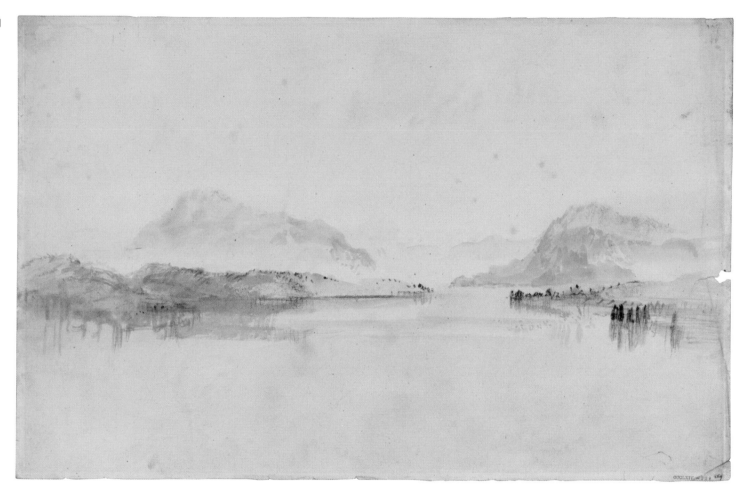

River, with Mountains Beyond
after c.1830
Watercolour on paper
24.4 × 31.1
Bequeathed by the artist 1856
D36063

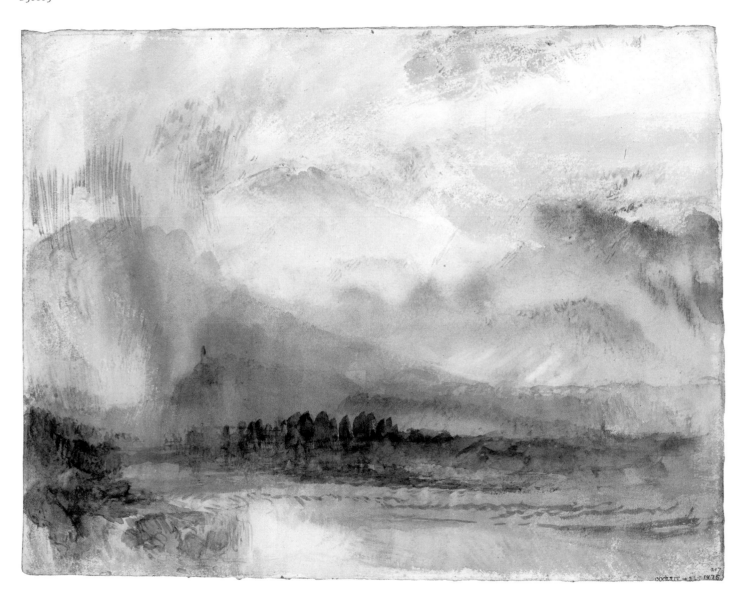

Venice: Looking across the Lagoon at Sunset
1840
Watercolour on paper
24.4 × 30.4
Bequeathed by the artist 1856
D32162

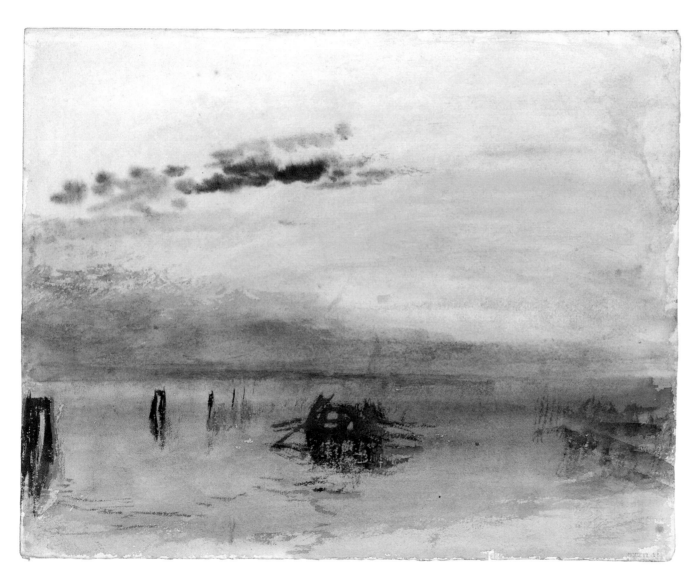

Fishermen on the Lagoon, Moonlight
1840
Watercolour on paper
19.2 × 28
Bequeathed by the artist 1856
D36192

Venice: An Imaginary View of the Arsenale
c.1840
Watercolour and bodycolour on paper
24.3 × 30.8
Bequeathed by the artist 1856
D32164

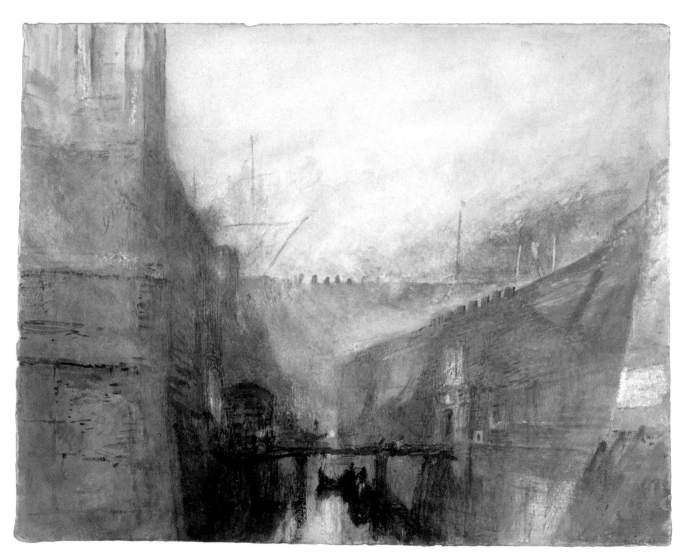

**The Rio San Luca, alongside the Palazzi Grimani,
with the Church of San Luca**
c.1840
Gouache, pencil and watercolour on paper
19.1 × 28.1
Bequeathed by the artist 1856
D32214

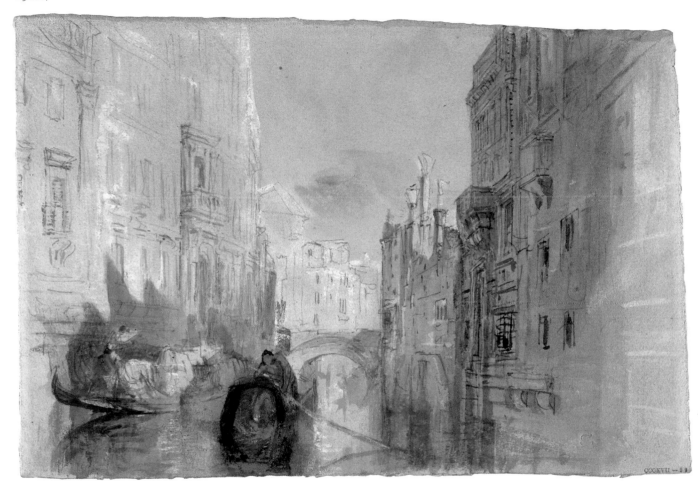

Ehrenbreitstein with a Rainbow

1840
Pencil, watercolour and gouache on paper
14.1 × 19.3
Bequeathed by the artist 1856
D28979

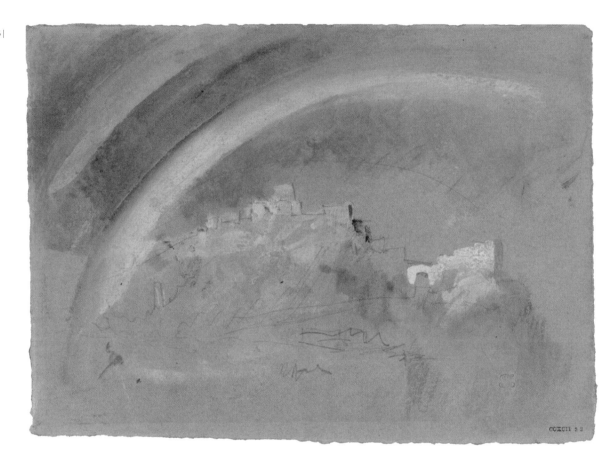

Passau from the Ilzstadt
1840
Pencil and watercolour on paper
14.2 × 18.8
Bequeathed by the artist 1856
D28993

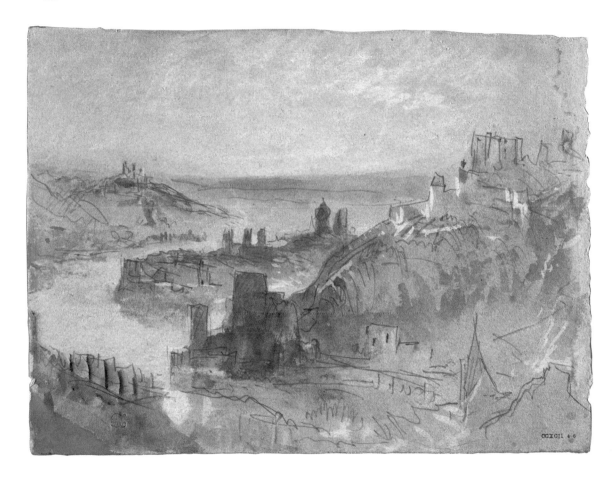

from Lausanne Sketchbook
Lake Geneva, with the Dent d'Oche, from above Lausanne
1841
Pencil and watercolour on paper
23.5 × 33.8
Bequeathed by the artist 1856
D33534

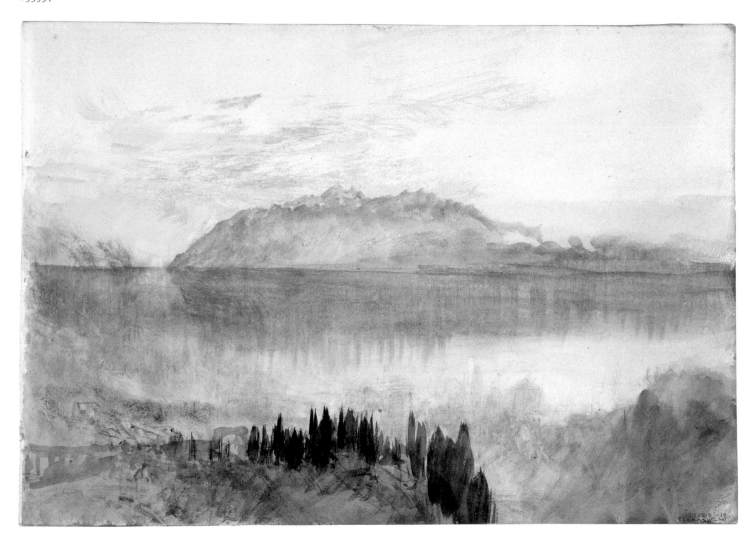

The Blue Rigi, Sunrise
1842
Watercolour on paper
29.7 × 45
T12336

Purchased with support from the National Heritage
Memorial Fund, TheArt Fund (including generous support
from David and Susan Gradel, and from other members
of the public through the Save the Blue Rigi appeal),
Tate Members and other donors 2007

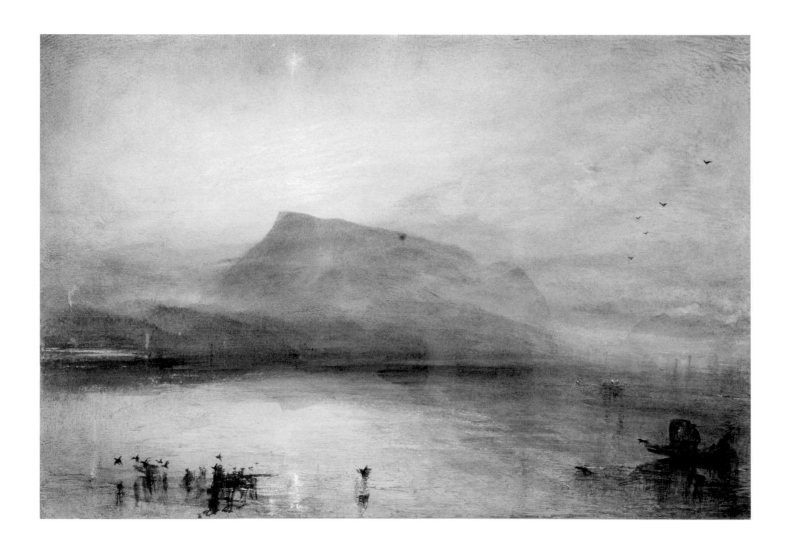

Küssnacht, Lake of Lucerne: Sample Study
c.1842–3
Pencil, watercolour and pen on paper
22.8 × 29.2
Bequeathed by the artist 1856
D36053

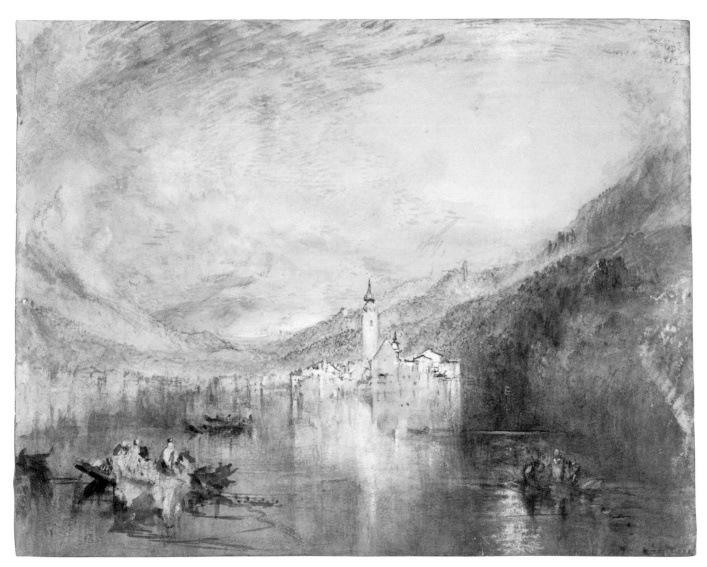

Storm over the Mountains
c.1842–3
Pencil, watercolour and pen and ink on paper
22.8 × 29.1
Bequeathed by the artist 1856
D36243

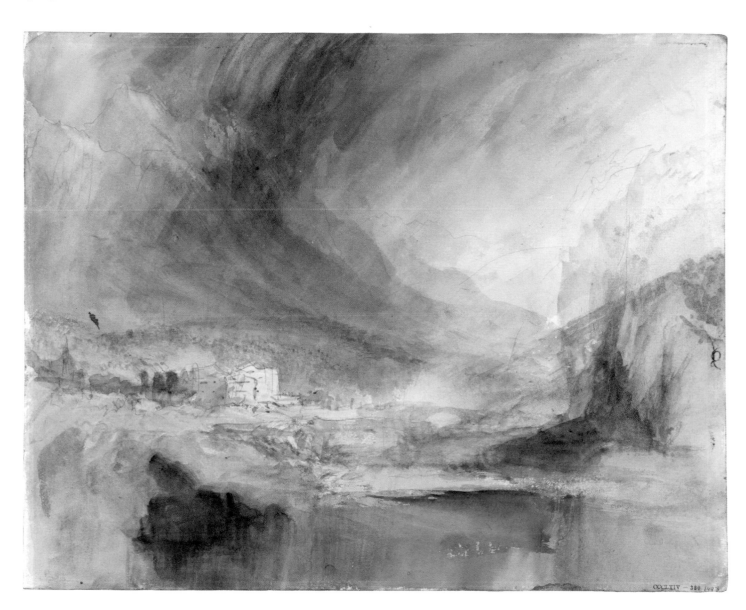

A Storm
c.1843-5
Watercolour on paper
29.1 × 47.9
Bequeathed by the artist 1856
D36300

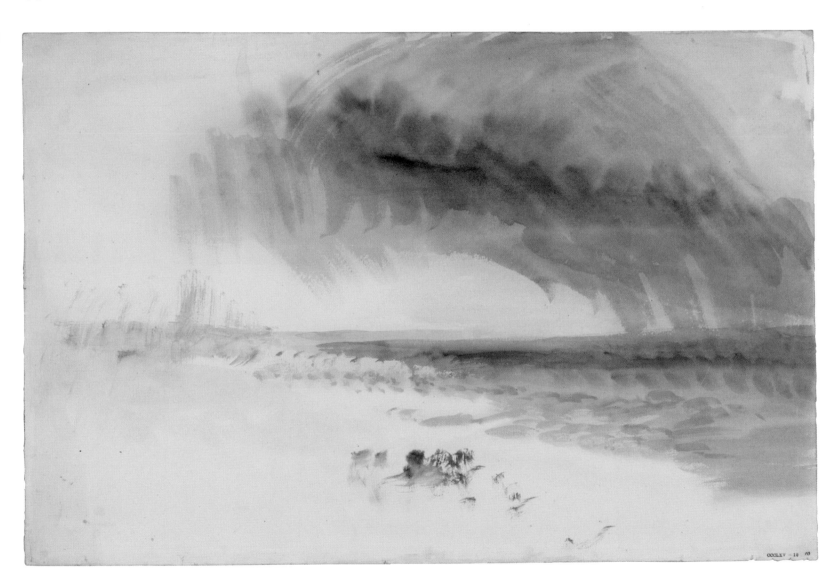

Yellow Sunset
c.1845
Watercolour on paper
23.6 × 31.4
Bequeathed by the artist 1856
D35950

from Ambleteuse and Wimereux Sketchbook
Storm Clouds, Looking Out to Sea
1845
Watercolour on paper
23.8 × 33.6
Bequeathed by the artist 1856
D35397

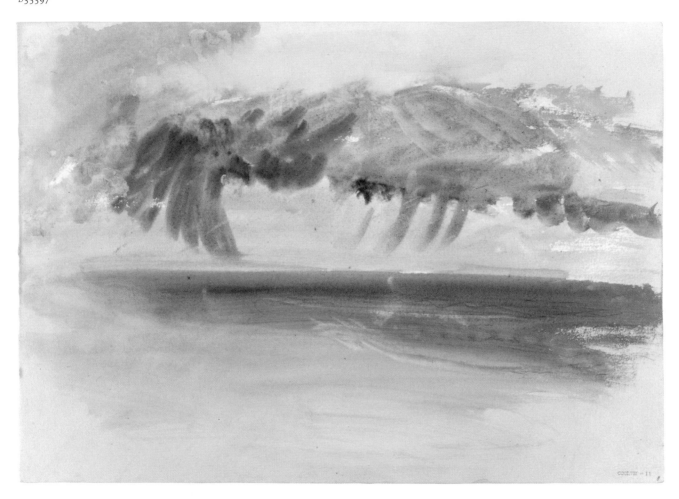

from Eu and Treport Sketchbook
Inside the Cathedral at Eu
1845
Pencil and watercolour on paper
32.6 × 23.2
Bequeathed by the artist 1856
D35445

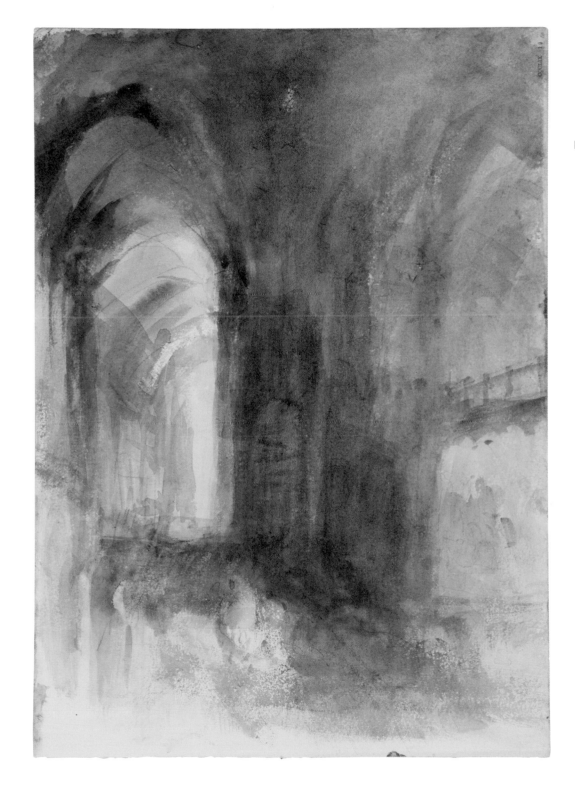

Index

Page numbers in *italic* refer to illustrations.

Index

Photographic credits

Unless stated otherwise all photographic copyright is held by Tate.

Fig.2 Yale Center for British Art, Paul Mellon Collection, USA / Bridgeman Art Library